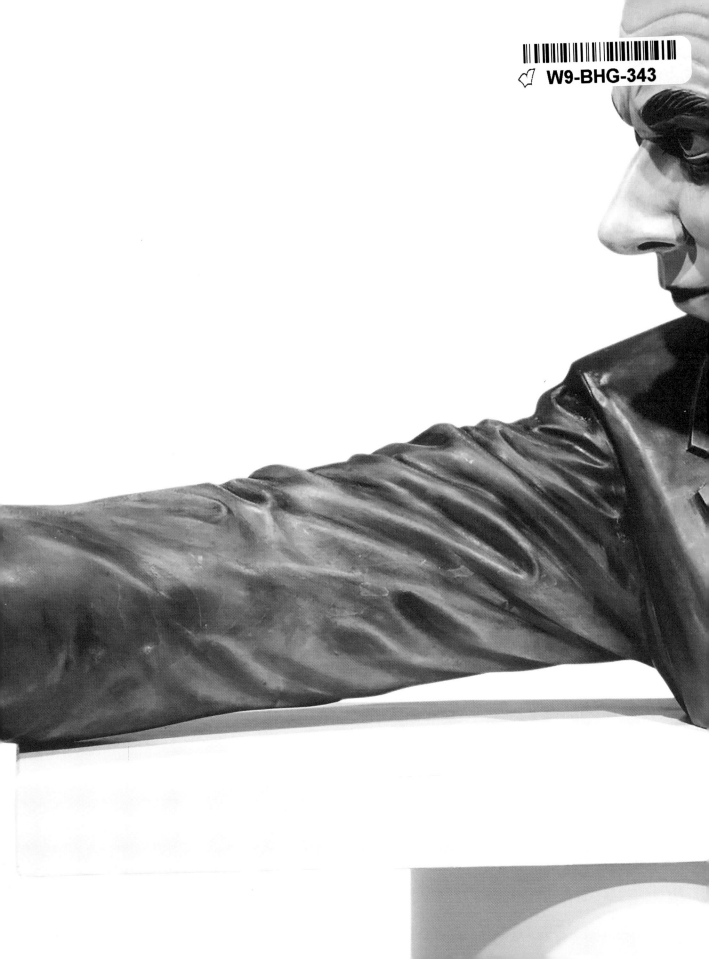

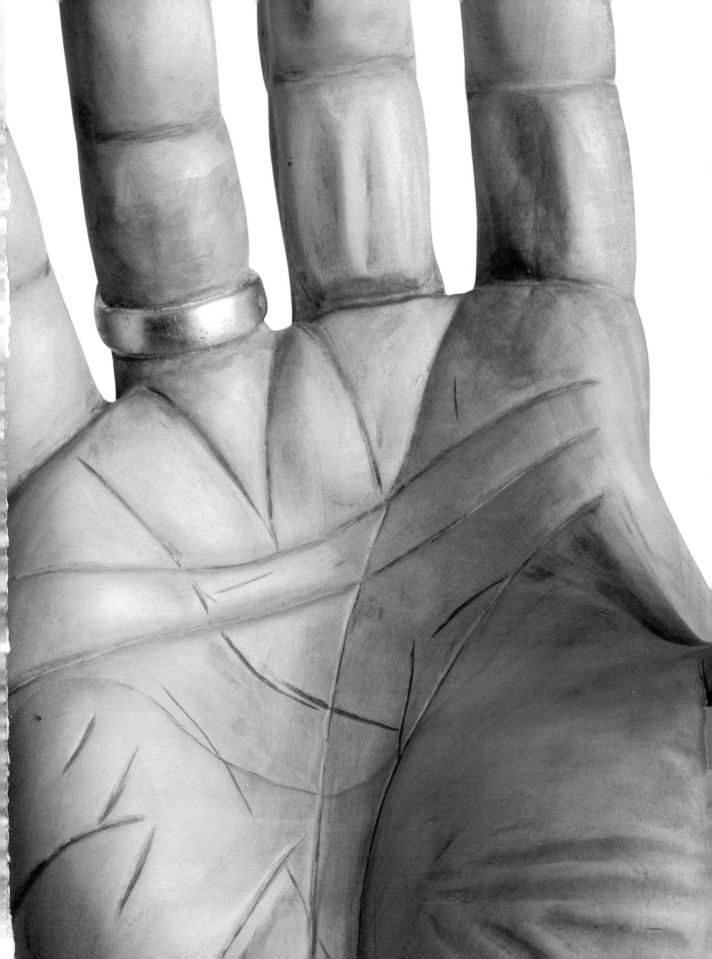

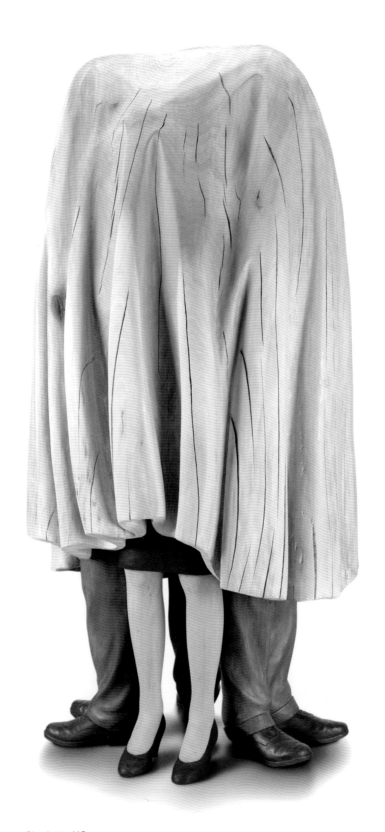

Cover Up, 2008
Wood, tempera
61 x 30 x 30 in.
Collection of the Mint Museum, Charlotte, NC
Photo: North Carolina Museum of Art

BUSINESS
AS USUAL

BOB TROTMAN

This publication accompanies the traveling exhibition
Bob Trotman: Business As Usual, curated by Lia Newman.

It has been produced by the Halsey Institute of Contemporary
Art at the College of Charleston in cooperation with the Van
Every/Smith Galleries at Davidson College, the Projective Eye
Gallery at the University of North Carolina at Charlotte, the
Gregg Museum of Art & Design at NC State University, and the
N.C. Arts Council, a division of the Department of Natural &
Cultural Resources

Published by the Halsey Institute of Contemporary Art
Editor: Mark Sloan
Managing editor: Katie McCampbell
Associate editors: Bryan Granger and Lizz Biswell
Copy editor: Harriet Whelchel
Graphic designer: Gil Shuler (gsgd.com)

Photo credits: David Ramsey unless otherwise noted.

ISBN: 978-1-4951-2864-6

Images of maquettes and preliminary drawings for completed
works are interspersed in the texts of this publication. Unless
otherwise noted, all images are courtesy of the artist.

Printed in the U.S.A. by Four Colour Print Group

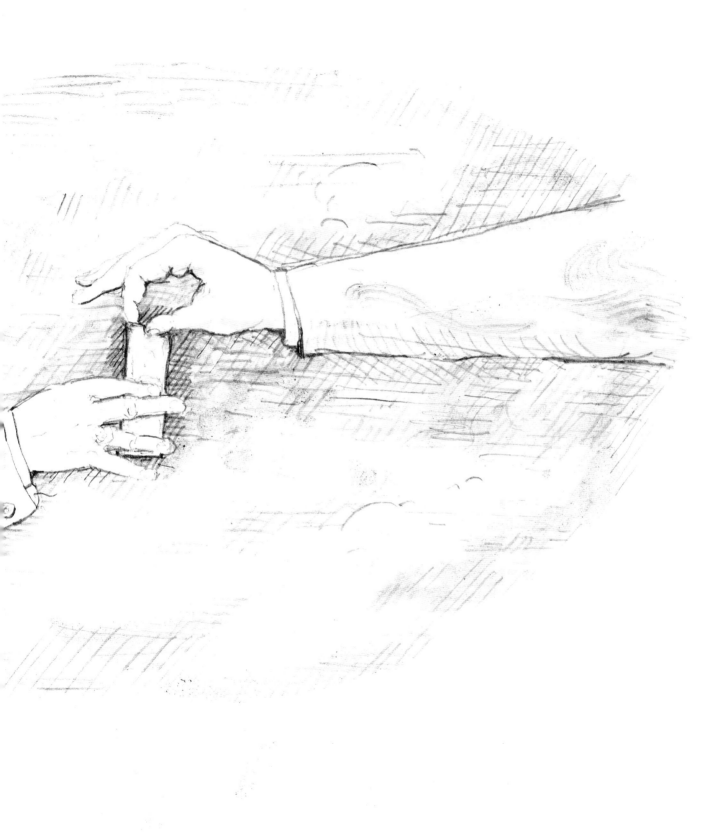

Contents

Foreword
by Mark Sloan............................8

Bob Trotman: The Search for Authenticity
by Lia Newman10

Minding Business
by Roger Manley16

Folio.....................................36

Bob Trotman in Conversation
with Crista Cammaroto.......................128

Biography...........................132

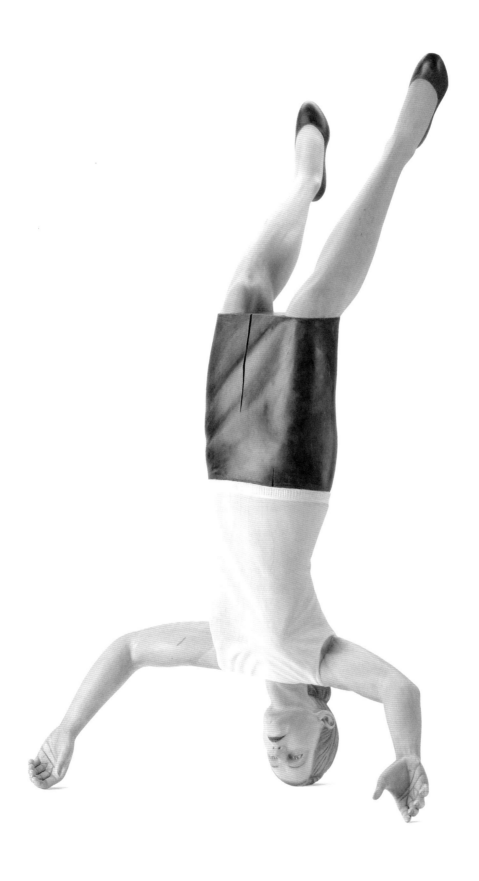

Uta, 2008
Wood, tempera
30 x 18 x 20 in.
Collection of Jeff Pettus
Photo: Bob Trotman

Bob Trotman: Business as Usual

I am his Highness' dog at Kew;
Pray tell me, sir, whose dog are you?

—Alexander Pope

*Epigram Engraved on the Collar of a Dog
Which I Gave to His Royal Highness (1738)*

Growing up in the shadow of a banker father whose three-piece suit may as well have been a suit of armor, Bob Trotman inherited a lifetime reserve of material from which to mine inspiration for his work.

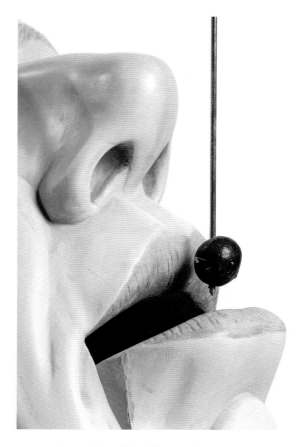

To hear him tell it, as you will read in his interview with Crista Cammaroto and his interactions with essayist Roger Manley and curator Lia Newman, he does not see himself as a victim in all of this; rather, he offers up a proverbial mirror to corporate culture so that we can see what he has seen from his privileged front-row seat.

Trotman's father was a hard man to please, yet he was also, to be fair, a product of his time. As a business-man in the 1950s, he was in many ways, emblematic of the ecosystem that laid the groundwork for the culture of excess that followed. It takes tremendous courage, strength, and honesty to look at one's own personal history with an unflinching eye. Produced in part out of spite for his father's banker persona, Trotman's work provides us access to the frightening faces behind the masks of corporate greed, but he does not wither from their stares. Instead, he revels in exposing the mean-spiritedness of their desires.

Now working in a variety of media, Trotman got his start working primarily in wood. He sees these early efforts in relation to the vernacular traditions of carved religious figures, ships' figureheads, and the so-called show figures found outside shops in the nineteenth century—often cigar stores. As a contemporary artist, however, he has chosen to create works that suggest an absurdist office-like arena in which we can see, more nakedly than usual, the elaborate posturing of power, privilege, and pretense that secretly, or not so secretly, shapes the world in which we live. If there were such a thing as corporate purgatory, this is what it might look like. His larger than life human figures, suffused with dread, melancholy, or grim determina-tion, are cloaked in the uniform of the powerful—a witty inversion of the cigar-store Indian of yore.

Now employing kinetics, video, latex molds, and an assortment of media, Trotman has expanded his visu-al vocabulary to include installations that incorporate the language of automatons. Their rote movements are a metaphoric exaltation of factory work, mimick-ing the tick tock of the company time clock. Trotman seems obsessed with the lock-step operations of the corporate machine: his subjects evince no joy, no soul, and no personality. They appear as replaceable, servile widgets in a perpetual giant cog: a machine that siphons money upward.

This publication is intended as a mid-career retrospective. Trotman has been making important and necessary work for decades, and his message has taken on even more urgency in Donald Trump's America, the moment in which this publication was born. Trotman's work is not so much an indictment of capitalism itself as it is a critique of what happens when the bottom line becomes the top priority. His perceptive work articulates the narrow boundary be-tween having enough and wanting it all. At base, Trotman is warning against the worship of the almighty dollar. Through his work, he demonstrates that we retain the ca-pacity of self-examination and reflection, and to that end, he is cautiously optimistic. His challenge to us, however, is to counter the money-grubbers with heart, soul, and pluck as a form of resistance.

Mark Sloan
Director and Chief Curator
Halsey Institute of Contemporary Art
College of Charleston

The Search for Authenticity

What is the nature of the search? you ask. Really it is very simple, at least for a fellow like me; so simple that it is easily overlooked. The search is what anyone would undertake if he were not sunk in the everydayness of his own life.

—Binx Bolling, in Walker Percy's *The Moviegoer*

In 1959 Peter Selz curated an exhibition at The Museum of Modern Art entitled *New Images of Man* that included the work of painters and sculptors such as Jean Dubuffet, Karel Appel, Leonard Baskin, Francis Bacon, Willem de Kooning, Nathan Oliveira, Leon Golub, and Richard Diebenkorn.

While the exhibition made direct connections between the work of these artists and their predecessors, such as Goya and Bosch, Selz's central thesis was focused, as the title suggests, around the artists' development of a uniquely twentieth-century image of man (and woman, we presume). Selz highlights human vulnerability, fragility, solitude, and ambiguity as key characteristics of the time.[1]

In Paul Tillich's introduction to that exhibition, the philosopher notes that each period has its particular, peculiar image of man, expressed in poems, novels, music, plays, dances, and, of course, visual art. He writes, "The works of art of our century are the mirrors of our predicament produced by some of the most sensitive minds of our time." Tillich's comment could, of course, apply to any century.

In 1959 Tillich prophesied that man was in "danger of losing his humanity and becoming a thing amongst the things he produces," and that there were "…few periods in history in which a catastrophic defeat was more threatening than in ours." Tillich's words came just fourteen years after the end of World War II, the internment of Japanese Americans in California, and the detonation of two atomic bombs by the United States in Japan. The United States had recently entered a war with Vietnam, was already engaged in the Cold War and the Space Race, and would anxiously watch Fidel Castro rise to power in the same year of Tillich's prophecy. The Cuban Missile Crisis and the assassinations of John F. Kennedy and Martin Luther King, Jr., were tragedies yet to come.

Rereading Tillich's words nearly sixty years later feels oddly reassuring. It provides a needed reminder that every era has had its troubles and disasters, and that, at the time, the masses believed with certainty these calamities were the most devastating to date, with the greatest potential for ruin. In 1959, just as today, the fall of our great empire seemed close at hand. Tillich reflected:

The impact of this predicament produces, on the one hand, adaptation to the necessities of present-day living and indifference to the question of the meaning of human existence, and on the other, anxiety, despair and revolt against this predicament. The first group resigns itself to becoming things amongst things, giving up its individual self. The second group tries desperately to resist this danger.

Artist Bob Trotman was just a child when Tillich penned his essay for *New Images of Man*. Trotman recalls being acutely aware of the potential impending danger associated with the Cold War, and certainly, as he approached draft age, the Vietnam War. But for Trotman, his school's bomb drills were countered by parties at the local country club. There was a fear for what the future would bring nationally and globally but, at home, Trotman's parents were hopeful their eldest son's future plans would include medical school. If that didn't work out, aspiring to any kind of business profession, like that of his banker father, would do.

As a young child, Trotman had very little understanding of exactly what his father did at the bank on a day-to-day basis, but he knew that his dad came home tired,

uninspired, and uninterested in engaging with his family. It was made clear that some of Trotman's pursuits, such as shop class and other activities that involved building things and working with his hands, were considered trivial or frivolous—skills associated with lower-class folks, not for those with their sights set on upward mobility.

Understandably, parents typically want more for their children than they have—new and better opportunities to succeed, fewer obstacles to fulfillment, an inside track to prosperity. The so-called American Dream—the ability to purchase a home, accrue wealth, get married, raise 2.5 kids and perhaps an obedient dog—occupies our country's ethos. The intensity with which our parents and grandparents ascribed to this concept, although it was devastatingly oppressive and overwhelming even for them at times, can also be the very thing that pushes one to swing far outside the norm. In fact, if Trotman's father had taken more interest in him, or if he had returned home from work rather cheery, perhaps Trotman would not have found the 9-to-5 grind so unappealing and disheartening. He might even have been duped into thinking corporate life was right for him, too.

In 2017, in his studio in rural Casar, North Carolina, Trotman confessed, gesturing toward his sculpture entitled *Floor Man*, that his "worst nightmare in the world would be having to be one of these guys, in the corporate world."[2] He noted his thankfulness for never having to venture there. After college he first worked as a teacher, then attempted poetry, followed by woodworking and furniture-making, before moving into fine-art sculpture exclusively around 1997. When Trotman graduated from college, hip tech start-ups and companies like Warby Parker, Google, and Twitter did not exist. Big business had not yet figured out how to create an alluring office culture centered around flat organizational structures, Ping-Pong tables, and unlimited vacation days. Such perks (along with incredible salaries and signing bonuses) purportedly attract the brightest minds and encourage innovation and creativity. Yet these environments still house corporate businesses with the same common capitalist end goals. This is at the heart of what Trotman's work—and lifestyle—resists. Trotman's resistance is somewhat of an existential endeavor for the artist, who as a young philosophy graduate was intent on abandoning the exclusivity of the country club in favor of what he refers to as a "poor farmer's house" on land in the middle-of-nowhere North Carolina. Trotman's choices align him with that second group Tillich described—those intent on preserving the individual self, unwilling to become "things amongst things."

Trotman's art does not "resist" in the same way that most contemporary art does today. His work is not socially engaged, nor does it toe the line of art as activism. Trotman is not necessarily offering his audience an alternative path or method toward a specific change. His sculptures and sculptural vignettes—finely crafted, primarily of wood, but at times also utilizing sound, light, movement, resin, clay, and more—critique big business, corporate greed, and capitalist corruption. They reflect onto us what Trotman perceives as problems in our society, without implicating us individually or personally.

In a time when the United States' newly elected president represents business more than politics and insists on a policy of "America first," it is hard not to view Trotman's sculptures as direct representations of specific current events; however, Trotman's interest is broader than politics, and the excesses his works emphasize are not new. Trotman reminds us that "Sophocles and Aeschylus understood it 2,500 years ago in ancient Greece. Arthur Miller put it on stage in *Death of a Salesman*. David Mamet underscored it in *Glengarry Glen Ross*. It is the relentless grinding of one life against another that we call history."[3] We can update these references to many contemporary moments, such as the 2013 film *The Wolf of Wall Street*, the 2015 film *The Big Short* and the 2010 book it was based on, Michael Lewis's *The Big Short: Inside the Doomsday Machine*, or to be even more current, the binary language of President Trump in which everyone is categorized as either winner or loser, ally or enemy.

Almost all of Trotman's sculptures depict men—primarily white men. In part, it is the point of view he most understands as a white man himself. "They are the problems,"[4] Trotman offers. An early series of works, *Model Citizens*, which includes the busts of *Stu*, *John*, *Tom*, and *Lisa* (all 2005), were modeled after friends, with the occasional look to world leaders for inspiration. With the manipulation of interchangeable carved wooden parts, these figures close and open their eyes, glance sneakily around the room, or purse their lips. The limitations of such movements—often not experienced by gallery or museum visitors because they require touching the sculpture—led to the artist's foray into kinetic sculpture, resulting in works such as *Fountain* (2014, 2017), *Waiter* (2014), *Slow Drip* (2014), and *Denier* (2016).

Trotman's recent works fall under the series titled *Business As Usual*, a phrase Winston Churchill made popular in a 1914 speech and resurrected again during World War II. Churchill intended the slogan to be a message of both defiance and hope. Business as usual—the idea that everything should proceed as normal, despite particularly trying situations—seems an appropriate heading for Trotman's recent cast of characters.

Defiance is explicit in many of his sculptures, including the two *Senior Partners* (male, 2014; female, 2016) and the *Clubman* (2011). All three figures, much smaller than

life-size, stand atop handmade safes, presumably full of money and valuables, and glare up at the viewer. They are menacing yet, because of their small size, are more comical than threatening. What shortcomings or insecurities are these little visualizations of Napoleon complexes attempting to make up for in their invocation of determination, force, and violence? The woman "partner," arms crossed, is adamant, rigid, unbending. Perhaps she is simply asserting her power in the face of gender discrimination in the workforce. She and her male counterpart, scowling, one hand curled into a fist, and *Clubman*, bat in hand, ready to strike, are focused on the task at hand, the prize, at all costs. But with whom are they engaged in battle? Perhaps the enemy is everyone and anyone in their way on the climb to the top.

It is conceivable that, in their defiance, Trotman's characters are reflections of the artist; he, too, is determined to get what he wants but his goals are far more positive. While *Clubman* and the *Senior Partners* are concerned with returns on investments, operation efficiency, and promotions, Trotman is motivated by freedom, equality, and authenticity.

In contrast to the aforementioned works, *Floor Man* (2011) is larger-than-life. From particular angles, it becomes clear that we are encountering our protagonist in the midst of his fall; his writhing body, in a fetal position, has not yet crashed to the ground. His legs and feet are raised from the floor, his suit jacket defies gravity. Trotman notes that "seeing a big person having a meltdown is disturbing."[5] *Floor Man* does not exactly embody defiance, nor does he encourage hope. He may represent one's fall

from grace, or a surrendering of some sort. Yet his large size positions him less as an individual businessman and more as a representation of the entire economic system. Perhaps his gesture refers to the downfall or collapse of this greater entity. Over the last decade, the warning signs for such a demise have included the 2008 burst of the housing bubble and the ensuing Great Recession.

Similar to *Floor Man*, Trotman's *White Man* (2015) also takes on an exaggerated scale. Trotman explained that "When I see the [larger-than-life figures] it makes me feel like a child…it's a grownup, I'm little. It's powerful, I'm not powerful."[6] The businessman, understood to be such from his stereotypical attire—dress shoes, a tie, a sports jacket, a signet ring—could either be flying or falling. Is he toppling over or sailing onward? The hollowness of the form situates him as an "empty suit," perhaps indicating that he is ineffectual or unqualified. Or, more likely, Trotman may be using this literal emptiness to point to an emotional one: the heartless or soulless work of big business. *White Man* assumes a similar position to that of *Vertigo*, a piece created in 2010. Museum curator Linda Dougherty notes that *Vertigo* may explore "the idea that in any human endeavor, there is always the possibility of losing your footing, of going into a free fall, of leaping into the void, especially when you are taking a risk."[7]

White Man wears an initial ring adorned with the letters "M E." Trotman has created several other works that also include monogrammed rings. The oversized *Me Ring* sits atop a spinning red-velvet stand with golden yellow fringe. With each revolution of the ring, the wearer's selfishness is driven home: me, me, me. The enlarged size of the ring further

emphasizes the wearer's self-determined importance. There is also a ring on the larger-than-life hand of *Waiter* and another ring on the *VIP Hand* (2013). Both are embellished with the letters "V I P," again, identifying the wearer as someone privileged and worthy of special access.

A ring also adorns the ring finger on the hand in the kinetic sculpture *Denier*. The letters "H A" are clearly delineated. In the work, a carved bust of a man sits atop a pyramid modeled from the Great Seal of the United States, seen on the national currency. A hand from above dangles a cherry on a skewer just within reach of the man's mouth. As the cherry gets closer, the motorized hand snatches it away. He has been denied. His mouth closes without obtaining the reward. The ring's insignia connotes that the game around access and denial is only fun for the person in control.

Similarly, *Fountain* and *Upper Hand* (2014) also explore the question of access. Trotman's *Fountain*, again a kinetic sculpture, features a man whose body comprises a safe. As he turns his head from side to side, his mouth opens and closes. Is he firing off commands? Or continually chomping down and gobbling everything up around him? The theory of trickle-down economics supposes that tax cuts and subsidies for the rich work their way down and eventually benefit the poor. In the case of *Fountain*, the man expels waste into a metal bucket from a perfectly positioned spigot on the front door of the safe. The yellow liquid is recycled through the piece continuously, reminding us that policies aimed at destabilizing the poor are institutional, constant. Nothing will change until something, or someone, disrupts the mechanism at work.

In *Upper Hand*, Trotman's only video work to date, a man's arm enters from the right side of the screen. He wears a black suit coat and his white dress shirt sleeve is visible. He holds a one-hundred-dollar bill, which he sometimes shakes tauntingly. One by one, hands reach out from the left side of the screen in an attempt to clasp the money being offered. In each case, whether man or woman, white or brown, wearing plaid shirt or suit coat, the money is always just out of reach. It slips between the reachers' fingers. As the video progresses, the hands on both sides multiply. The rich get richer, and the poor cannot catch a break. For the working poor, particularly in the South, wealth and social mobility are structurally so inaccessible as to be impossible.[8] Again, the repetition of this action reminds us of the systemic way in which social and economic structures keep people down.

Trotman's *Capitulation Device* (2014) rhythmically waves a white flag. Typically, white flags indicate surrender, but conceding does not seem part of Trotman's disposition. Art critic Eleanor Heartney notes that inside Trotman's

characters' eyes "are sparks of inner life that refuse to be extinguished."[9] Perhaps this is the closest his sculptures come to resembling the artist.

More than forty years ago, Trotman and his wife, Jane, elected to live in rural North Carolina, but this was not a concession. It was with the intent of creating a new reality for themselves. They wanted to live inexpensively and find their own authentic way to be. Through his primary choice of media—wood and sometimes clay—Trotman connects his work directly to the land and aligns himself with two long-standing traditions in the region. His conceptual notions, however, along with the incorporation at times of sound, light, movement, resin, and video, have elevated his work from traditional to contemporary, from craft to art.

Just as Tillich and Selz noted that the works in MoMA's *New Images of Man* mirrored their time and presented a cross-section of human behavior and traits in 1959, so do Trotman's sculptures in *Business As Usual*. Although not intended as visualizations of specific current events, Trotman's works can easily be connected to what we hear and see around us. In particular, *Trumpeter*'s proclamations— incomprehensible, incessant drivel—suggest the twenty-four-hour news cycle and nonsensical speeches from our elected officials. His characters, though familiar, are not based on real people. They are instead representations of everything the artist wishes to resist. They perfectly epitomize the "business as usual" slogan: brazen, greedy, selfish, insatiable, but also lost and under duress. Yet in their gross contradiction to Trotman's values—and, hopefully, our own—the sculptures can provide the viewer with affirmation of our life choices. We are not *Floor Man*. We have it under control. There is hope yet.

Lia Newman
Director/Curator
Van Every/Smith Galleries
Davidson College

Notes

1. Bob Trotman, in conversation with the author, Feb. 20, 2017.

2. Ibid.

3. Bob Trotman, *Business as Usual*, Artist Statement (Columbia, SC: 701 Center for Contemporary Art, 2010).

4. Bob Trotman, in conversation with the author, April 6, 2017.

5. Bob Trotman, in conversation with the author, Feb. 20, 2017.

6. Ibid.

7. Linda Dougherty, "Bob Trotman: Inverted Utopias," in *Bob Trotman: Inverted Utopias* (Raleigh: North Carolina Museum of Art, 2010), 39.

8. Despite the fact that Charlotte, NC, is a leader in economic development in the South, the city was ranked last (50th) in the Equality of Opportunity Project's study of social mobility. https://www.theatlantic.com/business/archive/2017/04/south-mobility-charlotte-521763/.

9. Eleanor Heartney, "Bob Trotman and the Religion of Capitalism," in *Bob Trotman: Inverted Utopias* (Raleigh: North Carolina Museum of Art, 2010), 55.

Minding Business

One hundred years from now, the people
who come after us, for whom our lives
are showing the way--will they think of us
kindly? Will they remember us with a kind
word? I wish to God I could think so.

—Anton Chekhov, *Uncle Vanya*

Scene One, Home:

Shiny, hard-topped shoes, buffed just minutes earlier. Tight laces disappear under pressed cuffs. Creases run straight up the trouser legs, disappearing under the dry-cleaned overcoat. The body inside the coat is as stiff and erect as a tree trunk; the undersides of chin and nose almost the only visible parts of the face. Father's been up for hours, but now the hat is on his head and his hand is reaching down to grab his leather satchel. You look up, wanting to ask him something but you can tell he's in a hurry. There's no time. A sleeve button flashes when the starched white cuff extends past the coat sleeve as he reaches for his keys. The shoes squeak; the door closes. From outside comes the sound of his car starting, then driving away. Like every weekday morning.

Late in the day, the order of sounds is reversed: the shiny car drives up, engine stops, car door shuts, front door opens, satchel hits the hallway floor. He drops into his favorite chair with a short tumbler of rye whiskey, iced and brown, by his side. You approach, but a hand goes up. "Not right now." You see the lines around the eyes and know he means it. You back away, go back to your room to tease a decal onto the other wing of the P-51 plane model you're assembling while you wait for the call to dinner.

When it comes, you and your younger siblings sit on the long sides of Mother's treasured antique table, listening to Father's comments on Khrushchev's speech and Eisenhower's response and what that'll mean for the shareholders at the bank. Mother offers her own update on her luncheon at the country club, and mentions her upcoming project as president of the debutante society. The silences in-between are interrupted only by the clinks of utensils on hard china. When they grow longer, you try to bring up your question again.

This time his face leans in close, inches away, filling the view. "Nossir," he says. "You're not doing that. That sort of thing's a waste of time." You almost say something, but he holds up his hand. "I don't want to hear any back talk." You know he means it and right away give up, finishing your plate in silence. When you're finally excused from the table, you retreat to the safety of your own room once again. You have no idea what he does at the bank all day, but it always leaves him tired and distant, at least around you. Around his adult friends he can be friendly and outgoing—that's business, after all—but never when it's just you. Later, you can't even recall what the question was. It must not have been important.

A classic cliché of Hollywood and Burbank is the breakthrough "Aha!" moment, when the troubled protagonist finally recalls some until-now-buried incident in the past when the railroad of his life got switched onto a different track that led, inevitably, to the straits being faced in the present. The incestuous rape, the parents' divorce, the secret adoption—some dire moment so traumatic that the nacre of time had walled it from view, but not quite deep enough to keep it from casting a pall over life until the present revelation.

When at last it resurfaces (perhaps while sorting out the deceased parents' correspondence, or going through the contents of the locked security box at the bank, or under hypnosis in a past-life regression, or on the psychiatrist's couch), the hero is flooded, first with dramatic grief, and then, seemingly within minutes, with tears of joy and relief. Healing is on its way! Now life can get back on track and return to where it should have been. By pinpointing the source of pain, it can be exorcised once and for all. Everyone hugs in relief as the credits begin to roll.

Real life, of course, isn't scripted by screenwriters. In real life, such realizations or discoveries—if they ever occur at all—just as often lead to further depression, confusion, and regret. And in real life it is much more common that instead of a single traumatic moment, one's path becomes another through a constant accumulation of little erosions that wear away bit by bit until they divert the course of life, like the way a meandering river eventually wears away at its banks until it leaves behind an abandoned oxbow. One is lucky if one can arrive at a degree of accommodation after recognizing what happened.

One is luckier still, however, if, instead of merely accepting the past, one can mine it as a source of creative inspiration. North Carolina sculptor Bob Trotman would place himself so lucky, for his own past—recalled as emotional, if not always literal, history—has served him well as muse and material.

Trotman was born in 1947 in Winston-Salem, North Carolina, a city whose duality was indicated not only by the hyphen in its name and the two communities that it represents, but also by contrasts between the races and the separate neighborhoods they inhabited, between modern industry and traditional hand craftsmanship, and between its wealthy home-grown aristocracy and the working-class population it employed.

The roots of these divides were established long before young Robert ever became aware of them. Salem was founded by Moravian settlers as a Protestant theocracy in which church elders were the final authority in every decision, from where one could live and whom one could marry, to what trade one could pursue. The needs of the religious community always outranked any individual's hopes or desires. Though small, Salem early on gained a reputation for its highly skilled and industrious artisans, who excelled in activities like making pottery, tanning leather, smelting and forging iron, weaving cloth, and building furniture.

Winston, founded more than eighty years later on land purchased from the church, was a major hub of manufacturing and finance. Its hierarchy was just as clearly demarcated as Salem's, only instead of church elders, the top of the pyramid comprised a handful of ultra-rich families whose social and commercial interests were just as interwoven as any in Renaissance Italy. Like the Medici and Peruzzi of fifteenth-century Florence, the core fortunes had been established by self-made entrepreneurs pioneering in banking and textiles; with the mechanization of tobacco production in the early twentieth century, even more wealth accumulated in their coffers.[1]

In Trotman's childhood, it was a Winston-Salem commonplace that nothing happened without approval from the nineteenth floor of the R. J. Reynolds building, where the son of the founder of Wachovia Bank (the region's largest) ran its largest tobacco company. Meanwhile, Wachovia, where Bob Trotman's father worked as a senior vice-president, was being run by a member of the family whose textile mills were the largest makers of underwear and seamless nylon hosiery in the world. For many decades, all three industries fit together as one powerful money generator. Only in recent years, with the shifting of tobacco sales and textile manufacturing overseas, has the impact of these three industries on the Winston-Salem economy begun to slow down.

The very richest families had built baronial mansions on adjacent estates northwest of downtown, where, for a time, they experimented with the English country-house system in which the "big house" where the owners live is supported by an attendant community of small cottage industries. Reynolda, the 1,067-acre estate of the Reynolds family, had its own school and church

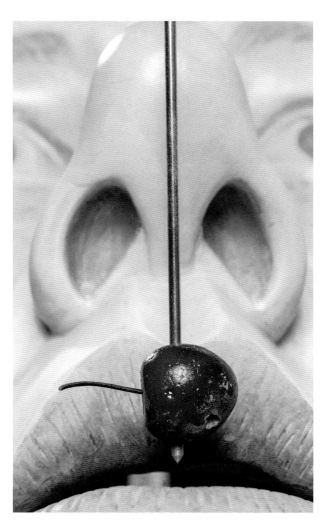

None of these estates (or others almost as opulent) thrived for long as exemplars of the English country-house system, for a variety of reasons. These ranged from the impact of the Great Depression, to climate (England has no equivalent to North Carolina's wilting summers), and to the developing aspirational awareness of the working-class people who had been counted upon to till the fields and shepherd the sheep.

Echoing the Renaissance oligarchs, once the founding fathers had developed the industries that built the family fortunes, their descendants felt free to pursue philanthropy, patronage, and civic service in addition to wealth and executive power. To be fair, this had a very salutary impact on the city's art economy. In the 1940s, wealthy Winston-Salemites established the Sawtooth Center for Visual Art and the nation's first arts council, and were later pivotal in establishing Piedmont Craftsmen (1964) and the North Carolina School of the Arts (1965). In time, several of them donated their former estates—which had become burdens to maintain and operate—to serve other purposes. In 1956, a portion of the Reynolda land became the campus of Wake Forest University, and in 1967 its mansion became the Reynolda House Museum of American Art. Graylyn was gifted to Bowman Gray Medical Center before becoming an International Conference Center in 1993, and the Hanes estate was bequeathed to the Southeastern Center for Contemporary Art in 1972.

When Bob Trotman was a boy, men like his father held these families in awe as aspirational beacons. Acquiring wealth was seen as a worthy life goal, one that M. Jack Trotman set for himself and hoped that his offspring would pursue as well. He determined that his oldest son should follow in his footsteps by going to a decent college, getting a degree in some business-related field that would qualify him for a job as a salaried member of one of the local corporations, and then he, too, could start climbing the ladder of success. With the elder Trotman's business and civic connections, he would be in a position to help his son get a leg up on that ladder. As the founding president of the Twin Cities Kiwanis Club and a regular on the country club golf course, he knew everyone who would be involved in making it happen. All Bob would need to do was knuckle down and follow the script, just as his father had done. The trade-offs—owing nearly all one's time to the company with almost none left over for things like children or personal intimacy—were just the price of admission. Either pay it or forget about it.

along with quarters for both house servants and fieldworkers, who managed herds of sheep and cattle, tended the gardens, ran the smokehouse, blacksmith shop, dairy, and carriage house, and stoked its furnaces and power plant. In theory, its employees need never leave the grounds, as long as they did their duties and met expectations.

Graylyn, commanding another expanse of pastureland and cornfields acquired from the Reynolds family, was at least as impressive. What the estate lacked in sheer acreage, it made up for in luxury. Built by a scion of Wachovia's founding family, it featured a Norman Revival exterior, a Georgian Revival living room, and an Italian Renaissance sunroom. Its sixty rooms comprised 46,000 square feet of floor space outfitted in Louis XV paneling imported from Paris, gold-plated bathroom fixtures, solid marble bathtubs, heated towel racks, and its own interior phone system, with fifty phones and an in-house operator. Like Reynolda, it included housing for servants and a farm operation as well. Abutting it was the Hanes estate, with its own English Hunt–style mansion lined with imported paneling and also surrounded by sizeable fields and woods.

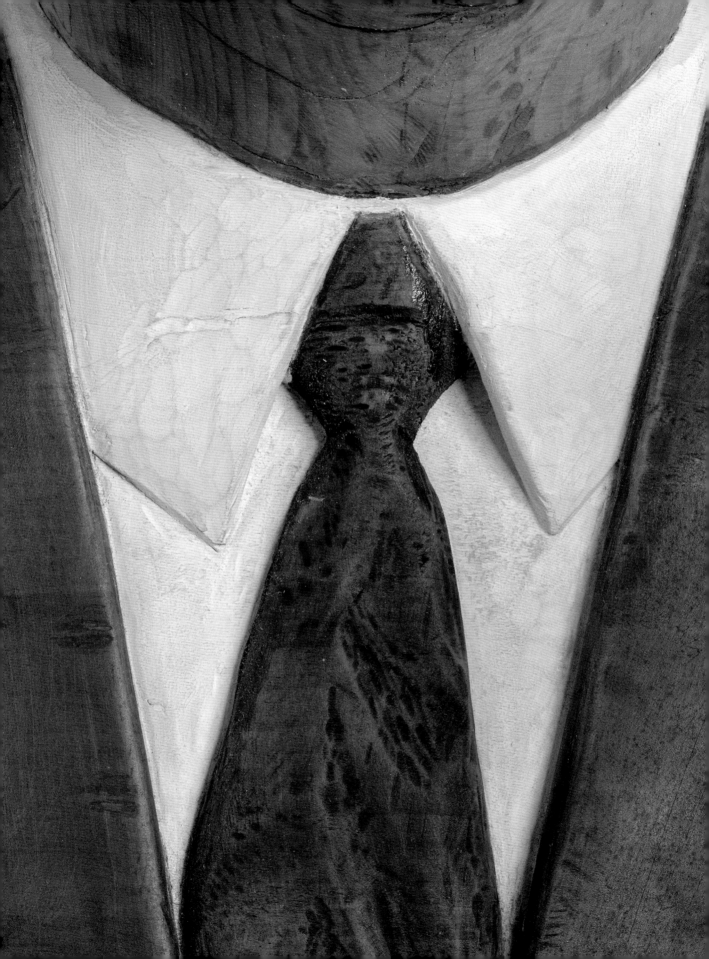

Scene Two, Uncle Frank's frame shop:

Music blares from the radio, the horn section making a brassy beep-beep-beep that somehow fits the scene: matt boards, papers, rectangular panes of glass are scattered about along with spools of picture wire, eye-screws, and nails; mitering machines, frame saws, matt cutters, glass cutters, hammers, and nail pullers; the smells of paint, turpentine, and varnish; the glint of loose flecks of gold gilding on carpet-covered worktables.

In racks on the walls hang empty picture frames, corners of frame molding, L-shaped samples of matt board. Prints, paintings, and photographs wait to be mounted and framed, or lean against the walls tagged and ready to be picked up. Out front, in the public part of the shop, the art is hung on the walls straight and level, but back here where everything happens, each item is only where it's handy.

The guys working with your uncle laugh at his jokes and wild stories, trading jokes of their own. Some of them are off-color, but Uncle Frank doesn't tone things down just because you happen to be in the room. He has a loud, boisterous voice, so different from his younger brother's—your father's—way of talking. His movie-star mustache and grinning good looks—like Errol Flynn or Clark Gable—are so different and so much more animated than your father's clean-shaven face and sober banker's mien.

Frank stops to critique something a customer left to be framed. "Damn silly way to draw a tree," he says. "It looks like a wad of cotton on a stick." He picks up a pencil and a scrap of paper. You watch his hands move rapidly over the surface, and in seconds a tree with leaves and real branches begins to appear, almost magically, almost as if drawing itself. "Here's how you draw a damned tree," he says, shoving the paper at you. It makes sense. Everything you see makes sense. Cut four pieces of molding at the right angles, coat their cut ends with glue, and nail them together—and hey presto!, a frame emerges. Measure and cut the window in a matt board, and put a print or drawing behind it. Suddenly the art looks valuable. Each step involved, every part of the process, is visible, logical, understandable. You can see how it happens. It makes sense, and despite Uncle Frank's reputation as the family rascal, seems honest.

That evening you're still excited by what you saw. You try to tell Mother and Father about the wonderful frame shop. But they look at each other, and say nothing.

Decades later, you're listening to the radio and that distinctive beep-beep-beep rhythm of horns catches your ear again. You stay with it long enough to hear the DJ identify it as George Gershwin's *An American in Paris*. With the sound of the horns, the rest of the scene floods back as you recall that afternoon in the frame shop. It suddenly dawns on you that somehow you never went there again. No edict had ever been openly declared, but it was more like a fact of the cosmos. Hanging out in that kind of place was something you just couldn't do. Each time an opportunity to go there had come up, it had always been deflected.

For a long while, Bob went along with the program. As a teenager, he took advantage of his parents' country-club membership to use the pool, where he hung out with the sons of other executives and professionals and shared their idea of humor, which often pivoted around drawing distinctions between an "us" and a "them."

"It was slobs and snobs," he later recalled. "We were the snobs, though we didn't call ourselves that. The kids whose parents couldn't afford to join were the slobs. Only we called them 'skoads,' which meant something a lot worse."[2] The divide was clear: There were the "nice people," who belonged to the club, held good jobs, and made lots of money, and then there was everyone else, who barely counted. In a town whose hierarchies and strictures of one sort or another had been in place for nearly two hundred years,[3] it all seemed natural. As long as he could hold his own in the "in" group, there was little reason to question, much less buck the system.

Still, the steadily increasing distance between him and his father was beginning to erode away at his certainty. The face his father showed the world—all handshakes and backslaps—seemed so different from the uncompromising face he wore when it was just the two of them. Although that face had yielded to smiles for a brief while after Bob asked his mother why his father didn't love him, the obvious effort involved in trying to be friendlier to his son (at her request) made it even clearer that something irreconcilable lay between them.

Going off to college came as a relief. His father had gone to Chapel Hill and his mother to Randolph-Macon, so it was a given that he, too, would go to a "good school." But to avoid following their leads completely, Bob applied to Washington and Lee in Lexington, Virginia, and got in. Even there, though, the basic script had been laid out by his parents. He joined a fraternity, partly for the fun and companionship but also because he'd been told that it would ultimately be good for his future career. In 1965, the corporate career was still a part of the plan.

It was not long, however, before he began to individuate and break away. He let his hair grow long, and began wearing bell-bottoms. In his junior year, just after 1967's Summer of Love had begun radiating its counter-cultural energies from the West Coast, Trotman dropped out of his fraternity and declared a major in a distinctly non-business field: philosophy. His parents were not pleased.

At the time, the professors in Washington and Lee's philosophy department were enamored of Existentialism, which emphasized "the freedom of man and the responsibility to make choices, decisive choices for yourself, and also the absurdity of life."[4] Trotman began reading texts by Kafka, Kierkegaard, Sartre, Heidegger, and Nietzsche, forming a new and, for the first time, personal world view, which began to throw his life up to then in high relief. This new way of thinking wasn't automatic or easy because, as he later explained, "With the freedom comes anguish, because you don't put the responsibility for your life off on society or institutions. The existentialist outlook is that you are radically free and that you always have a choice. It is exhilarating, but it's also a source of anguish and vertigo."[5]

By the time he graduated from college in 1969, the Vietnam War had reached a fever pitch and was consuming America's young men at a rapid rate. He had been safe as long as he was still a student, but now Trotman's draft lottery number was low enough to put him in danger of being conscripted. Meanwhile his philosophy degree was of little use as far as offering him many viable ways of making a living. But there was one: a special deferment for teachers. He and at least one of his classmates signed up for the program. Trotman was sent to the Christ Church School for Boys in Urbanna, Virginia. Here he struggled to teach English and American literature among colleagues who were mostly retired military officers, and who were not at all pleased to have what they regarded as a draft-dodging hippie in their midst. Still, he soldiered on for three years before transferring to the Lake Forest Academy near Chicago. Then, when his number wasn't called for the draft of 1972, he knew he could stop teaching; he had done enough public service to satisfy the rules. By then he had been married for two years (he had met Jane Bartlett in college), and thought it was high time to do something proactive. Now he could actually take the kind of existential responsibility for living intentionally that he'd only studied in college.

While the extroversion that effective teaching required had been a real effort—enough to convince him that pedagogy was not his strong suit—straining to instill an enthusiasm for literature in his young charges had left him with his own deepened appreciation for the act of writing. He determined to become a poet.

Unfortunately, it didn't work out. After he and his wife moved to rural Marshall, Virginia, at the foot of the Blue Ridge, she worked while he shut himself in a room and

tried for months to plant one word next to another in appropriately poetic ways. Somehow, though, the results never seemed adequate; being a poet turned out to be far harder than he'd ever imagined. Six months went by with almost nothing to show for his efforts.

Salvation came in the form of an invitation to come back to North Carolina, not to live in Winston-Salem, but to settle in a place even more remote than Marshall. A few friends were setting up a group-run farmstead in rural Rutherford County—what might be called a commune, in hindsight—and wanted to know if he and his wife like to join them? They decided to go for it. Years later, Trotman would point to this as a pivotal moment, comparing it to a famous 1960 image by Yves Klein, *Le Saut dans le vide* (Leap into the Void), in which the French artist seems to be taking a flying leap off a stone wall.[6] The startling image captures Klein at the precise second when it seems as if he might actually be taking flight instead of crashing to the pavement below. That most people who saw it knew the artist wasn't killed or crippled suggested that perhaps the seemingly impossible had really happened: he had flown after all.

The void Trotman leaped into in 1973 was a decrepit farm in North Carolina's South Mountains, where he, his wife, and several friends moved into a derelict barn and endeavored to begin living off the land. Each took on roles that seemed to suit their aptitudes, following the dictum, "From each according to his ability, to each according to his needs."[7] Years spent building airplane models on his own had left Trotman with a degree of manual dexterity and confidence around tools. He had loved his eighth-grade shop classes, where he got to turn a bowling pin on a lathe and make a gun rack with a band saw, but it had been another short-lived experience. When he wanted to sign up for more manual-arts classes the following year, his parents wouldn't allow it. Even so, his background in practical work was already more than that of any of his fellow communards, and before long he was designated as the group's carpenter.

Following instructions in the *Foxfire* series of books[8] and others that could be ordered through Stewart Brand's *Whole Earth Catalog* (which catered to the resurgent back-to-the-land movement of the late 1960s and early '70s), Trotman taught himself the rudiments of woodcraft. He learned to use tools like drawknives, adzes, and froes, which had absolutely no connection to the world of banking, business, or literature, but felt immensely satisfying to work with. Every stroke had an instant and obvious result; at the end of a day of cutting and shaping wood and driving nails, the outcomes were immediate and tangible. The feeling of seeing and holding the results of his efforts and recognizing the one-to-one correspondence between action and outcome—"I made *this*," "I did *this*"—was quite unlike anything he had encountered in college or the classroom, or had ever expected to find in the corporate world. He felt he was on his true path.

Working with wood and actually making real things satisfied a hunger that had gone unsatisfied for so long that he had become unconscious to it. The curl of shavings off a sharp plane blade, the smell of wood when it was sanded smooth, the opportunity to let his mind wander and think about other things while working—everything about using his hands and working with wood had an intense appeal that answered a deep need he had never felt before.

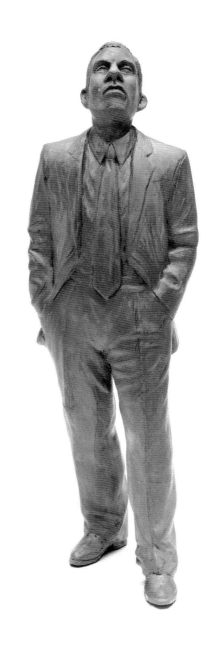

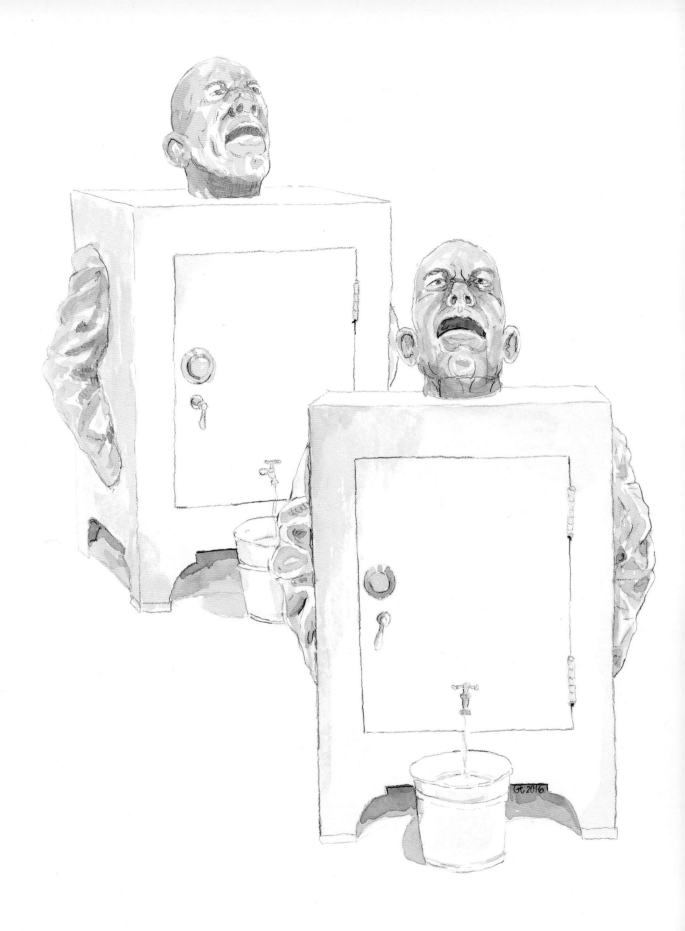

Scene Three, Grandmother's parlor:

A curved-front cupboard sits in its corner. Behind its glass-paned doors stand nearly a hundred little wood-carved peasant figurines Grandmother had brought back from her trips to Switzerland, Greece, and other European destinations in the 1930s: musicians, milkmaids, chimney sweeps, shepherds. A fisherman mending his net. An accordion player. A Frenchman in a knit cap, smoking a curved pipe. Only four or five inches tall, each figure had its own soulful or animated expression. If you seemed fascinated, Grandmother might open the doors to let you have you a closer look, and when she did you could smell the aromas of old wood and far-off places wafting from inside. It was a whole crowded, aromatic little city, wonderful to see. Everyone in it seemed busy and engaged, plying the trades indicated by the tools and attributes held in their hands or leaning against their little wooden thighs.

But your father's mother could be, if anything, even more stern around children than her son was. She always hovered nearby, making sure you didn't reach out and try to touch anything. The wood was dry and the figures were fragile. You could look, but the doors soon closed again, and a melancholy descended. Now the figures seemed trapped, diminished, distant behind their wall of glass. The babble of foreign tongues and marketplace sounds you'd imagined became muffled, silenced. Each time she let you look, the pleasure was always tinged with a little sadness.

As Trotman grew to appreciate the rewards of his own efforts, he began to admire the skills and accomplishments of the rural people he found living in the immediate region surrounding the farmstead. When the group's garden patch faltered while their illiterate neighbors' thrived, or a snuff-dipping hog farmer knew how to fix a pump that had baffled the college graduates who broke it, it became easier to appreciate the hard-earned wisdom of the kind of working-class folks he had looked down on so arrogantly most of his life until then:

I think the scales fell away from my eyes. Part of the reason that it was attractive to me to be here was that there weren't any people like my parents or the country-club people [here], that they were all away somewhere else, and it felt like to me was that I was really free and nobody was watching me. . . . [It] was just a tremendously liberating feeling. And also to see that the people that [had been] beneath the radar were real human beings that had their own problems [and] weren't just happy poor people. . . . [My parents] had always given me to believe that if you were poor, that you just got your paycheck and then you were happy and you went out and got drunk and then went back to work. It was a mythology that let the middle class off the hook for any kind of responsibility for anything they were doing. So I became a little bit more politically aware of the interactions between the classes.

And I think some of what was going on was that coming here and living the life I began to live in 1973 was that it felt real. My life up till that time only rested on what my parents had told me, but I couldn't touch the ground with my feet. It was like I was treading water in this imaginary world, but I had never touched the bottom.[9]

That same year, Trotman made his first successful piece of furniture, a coffee table with curved, cross-over legs commissioned by a Winston-Salem friend of his mother's. This soon led to other commissions, which kept a small amount of cash flowing while he continued to develop his skills. Making furniture was not only rewarding in its own right, but—because at first much of it was made for family friends—permitted a subtle way

of thumbing his nose at his father. Each piece said, in effect, "*You* may not respect what I'm doing, but a lot of your friends do."

There was a subtle Oedipal element to the situation as well. His mother had long treasured her collection of prized eighteenth-century antiques—an ornately carved table made by Duncan Phyfe that could seat twenty-two people when fully assembled, some original bow-front Sheraton and Hepplewhite linen presses with drawers veneered in matched exotic woods—and he subconsciously felt that perhaps her appreciation for fine furniture might transfer to him:

I think for her it was a real mark of gentry to own [and] to eat dinner on a Duncan Phyfe table. . . . All of that stuff was very powerful to me: old money, refinement. I think the bottom line was that my mother valued that [and] I wanted my mother to love me. So if I made furniture, [I thought] she would love me, or something like that. [Making furniture] is a good thing because she loves this. And it was something that was planted in me on a deep level. The message I got was not to be a banker, so that I could buy this stuff; it was to be an artisan so I could make it. So somehow I put myself on a servant level. I didn't see myself as being of the same class that my parents were. I saw myself as being a servant to my parents.[10]

Trotman understands this now, with the benefit of long hindsight and much thoughtful introspection, but his motivations were not necessarily so clear to him at the time. Nevertheless the satisfactions he felt were authentic and were strong enough to motivate him to continue. He felt that his real career was finally launched.

Over the next years, he deliberately accumulated tools and honed his talents as a largely self-taught furniture maker, "learning by doing" and only seeking help when he absolutely needed it, preferring to work out solutions to problems on his own as much as he could. At first, the slowness of his process made it hard to earn a living wage, but by working as a librarian at a local community college while Jane was a stay-at-home mom, he was able to supplement the money he was earning from selling cutting boards and stools at craft fairs and taking on occasional commissions for bigger projects. In time, his skills advanced to the point that he was accepted into Piedmont Craftsmen, Inc., a guild for craft artists whose imprimatur meant access to a much wider and more affluent audience of collectors and museums.

Although Trotman had heard of the Penland School of Crafts and it was only about an hour's drive from the studio he'd built on their farm near Casar, North Carolina,

several years passed before he took his first Penland workshop course in 1976. New Hampshire–based artist Jon Brooks's work struck a balance between a playful "twiggy" style, which that respected the original shapes of the roots and branches he began with, and careful painting and a high degree of finish. In Brooks's work, the line between craft (furniture) and art (sculpture) was almost impossible to draw. Trotman's pieces had already begun to straddle that same line.

A second Penland course the following year, with master furniture maker Sam Maloof, had more immediate impact on Trotman's way of working. Maloof was a consummate craftsman, whose precisely fitting dovetails and keyed mortise-and-tenon joints showed Trotman how to build strong structures with wood so that he might begin thinking beyond the limitations of the original materials and be able to construct nearly anything he could imagine. From Maloof, Trotman learned how to turn the inherent limitations of wood as a medium—with its directional grain structure and the way it reacts to changes in humidity—into opportunities for creating new forms. Trotman's background in teaching English literature and trying to write poems had left him with an appreciation for how boundaries, like those imposed by metric rhythms and sonnet forms, could be turned

to advantage. Maloof's techniques for fitting joints and solving structural problems to assemble chairs was not unlike fitting rhymes and measures to build poems. Trotman had, in fact, already been exposed to Maloof's influence when his father-in-law gave him a book featuring Maloof's woodwork while he was still struggling to become a poet in northern Virginia.

Later courses with James Surls and Robert Morris at the Atlantic Center for the Arts in New Smyrna Beach, Florida, and with Francisco Rivera at the Sculpture Center in New York, were also important experiences in Trotman's continued growth as an artist. The impacts these made on his development owed less to the techniques he learned and the art he was exposed to—although vortexes, storms, and tornados, recurring themes in Surls's work at the time, also appeared in some of Trotman's furniture—than to their living examples as working artists and direct encouragement of his own efforts. "[It] really is a boost to have somebody that you admire put themselves in a mentoring position, because what it does, is it . . . tells your superego to give you a break. The part of my brain where my father is [gets] reversed. It's like, instead of there being somebody who says, 'What are you doing that for?', there is somebody that says, 'Why not? Come on. Go ahead.'"[11]

Surls, in particular, left a lasting impression with his no-holds-barred, full-steam-ahead way of attacking artistic problems and exploring ideas. After spending three weeks with Surls, Trotman left Florida feeling energized and more willing to explore sculpture. Although Trotman continued to accept commissions from time to time, he began making pieces without worrying whether they would sell or not. The more he began to feel confirmed in his own choice of career path, the more the pressure to do things that might please his mother and confound his father began to diminish.

Even so, the transition from being a working craftsman who made studio furniture to becoming a full-time sculptor was gradual. Pieces from the late 1970s and early 1980s, like his *Dancing Tables* (1981), had featured curvy legs and daring colors and exuded a lively energy that made them seem capable of animated motion, yet they remained clearly in the realm of functional objects. Although the works were attractive and impressively crafted, one could still park a lamp or a magazine on them without diminishing their role. The real metamorphosis emerged when human faces, hands, and bodies began to appear in Trotman's desks and chairs with increasing frequency after their first appearance in the mid-to-late 1970s. This was hardly a leap in the history of furniture,[12] but it marked the slow emergence of the fully committed artist Trotman eventually became.

Meanwhile, the liminal hybrid work he was making—chairs with human arms and torsos, benches and tables supported by opposing caryatid figures, moveable library

steps carved to resemble hunched-over slaves—derived much of their energy from what Trotman called the use of "furniture 'language' to make its point."[13] As he explained it at the time, "The use-value is partly symbolic. It acts as a grounding factor for the art, and becomes a kind of theater if you want to tune in to it on that level. . . . Seeing fine art as the object of contemplation and decorative art as the object of use excludes the possibility that it too can solicit the contemplative gaze. There's also the possibility of contemplative use, which doesn't have to be dead serious, either. . . . You can enjoy the irony."[14]

Part of the irony, however, stemmed from the difficulty of engaging with serious subjects while the play between furniture and sculpture was going on. Although a piece like his 1990 *Testosterone Table* (also titled *Table with Walking Figures*), strove to make a statement about the male tendency toward blind bullheadedness (below table level, two nude figures with full male genitalia head off in opposite directions, while only the tops of their bald crania project above the tabletop), gallery audiences often saw it more as a farcical joke than as social commentary: "I kind of have to accept that part of the joke is on me. I'm doing something that, in a way, people are laughing at, rather than with, me, but I can accept that. . . . I wish I could be funny when I mean to, and then sometimes I'm funny when I don't mean to be. But if it works on some level, then I guess I've got to be glad that it does, even if it isn't exactly the way I intended for it to come out."[15]

Trotman points to an encounter with sculptor Martin Puryear during a week-long workshop at Penland in 1997 as the moment when he finally made the break, transitioning from making fine crafts and functional pieces to exclusively making art. Until then, he had continued to pursue both, either by addressing separate audiences (showing sculptures at the Nexus gallery in Atlanta in 1992, for example, while showing only functional work in Piedmont Craftsmen group sales) or, rarely, in combination, such as in his 1994 exhibition at N.C. State's Gallery of Art & Design, *Bob Trotman: A Retrospective of Furniture and Sculpture*. Even there, however, the presentation was essentially separate-but-equal: "I was afraid to tell people who saw me as a sculptor that I made furniture, too. It felt really bad. It was like I wanted to have a pseudonym. If you were a writer, you could do that, because you don't have to show up at an opening. [But] there was no way to do that. . . . I felt myself trying to go down two roads at the same time. And it just felt real bad."[16]

But at Penland, Martin Puryear, who had long been one of Trotman's art-world heroes, opened the door to doing

art full time. During a workshop critique session, Puryear saw one of Trotman's pieces and exclaimed, "Oh, you're a sculptor!" With that, a wave of relief passed over him. "It felt like permission as well as confirmation. Now I could give up the pretense. Now I could be an artist—something I'd wanted to be for as long as I could remember, but had never dared let myself accept. After thinking over what Puryear said, and other things he said later, I felt validated. It was like I was authorized to become an artist."[17]

Puryear not only corroborated Trotman's deepest impulses but also gave him permission to take bigger risks, which included the risk of failure. Later in that week, Puryear, who was given to guru-like pronouncements, told the students that often a piece becomes ". . . a work of art only through an act of grace. You do the best you can do and then if it makes it into being art, it's like it's sort of beyond your control. You can throw it out there as well as you can and sometimes it makes it and sometimes it doesn't."[18]

With his new-found freedom, Trotman began to feel more and more empowered to express himself. Making fine crafts depended largely on demonstrating technical prowess through the skillful manipulation of materials and technical mastery of a particular medium, but this focus began to give way to a greater concern with subject matter. Craft-making as an end in itself no longer felt satisfying enough to sustain him. From then on, content would take precedence over professional polish: "As historically figuration has often drawn its narrative structure from classical mythology, I [began] substituting for this a sort of contemporary cultural 'mythology,' not a specific set of stories but something like it, made up, for me at least, of bits of Freud, Kierkegaard, [French theorist Jean] Baudrillard, Marx, Kafka, Woody Allen, Susan Sontag, feminist theory, *All Things Considered*, and *The New Yorker*."[19]

In parallel with Trotman's growing concern with content was a deepening appreciation for the lessons to be learned from studying art history. Artists like Pieter Bruegel the Elder, Honoré Daumier, and Francisco Goya had taken on subjects like class, war, greed, and power—all issues that resonated with Trotman, whose immersion in literature and philosophy had made him aware of his privileged upbringing in contrast to his greater appreciation for the rural working-class neighbors he had come to respect and appreciate.

For inspiration, he hung in his studio an enlargement of a 1558 etching of a painting by Bruegel entitled *Avaritia* (Avarice). Its composition centers on a stylishly dressed woman who represents the personification of greed, blithely gathering coins in her lap while seemingly oblivious

to depictions of the consequences of avarice surrounding her. Behind her, a usurer (her husband?) gathers piles of money on a squalid table while at her feet a poisonous toad, long a symbol of evil in Christian art, squats above a caption that translates as, "Scrimping Greed sees neither honor nor courtesy, shame nor divine admonition."[20]

Trotman also hung a photo of Italian sculptor Gian Lorenzo Bernini's 1619 marble bust *Anima dannata* (Damned Soul) in his studio. The figure's animated expression is intense but ambiguous; it is hard to tell if the figure is screaming in agony or laughing with glee.[21] It was not only the bravura technique but also the figure's ambiguity that appealed to Trotman's appreciation for the complicated relationship between humor and pain. At the core of every joke runs a vein of agony or misfortune.

German Gothic sculptor Tilman Riemenschneider became another touchstone. While Riemenschneider's woodcarvings of saints exude a calm dignity, unlike the exaggerated expressions of Bernini's figure, he countered it with distorted anatomical proportions (his heads are often over-large in relation to their bodies) and in his careful attention to the depiction of garments. As Trotman found his confidence as a full-time artist and started to explore his new subject matter—the corporate world—he appreciated the importance of both these qualities, but especially the latter. He had reached a high degree of skill in carving realistic nudes but realized that without including clothing as a symbolic element, it would be almost impossible to make the points he was now determined to make.[22] For figures to represent the roles of "businesspeople," they would have to be dressed in business suits.

After studying how Riemenschneider translated clothing and accessories into carved wood, Trotman expanded his own technical vocabulary to include the starched shirts, pressed suits, and shiny wingtip shoes of the business executives he wanted to lampoon;[23] however, he deviated from the German master's lead (and his own approach up to then) in one significant way. Riemenschneider had left most of his limewood saints unpainted, as had Trotman, but now he didn't want viewers to get hung up on virtuoso carving instead of considering the implications behind the figures depicted. They would need to be painted.

Even so, he chose thin casein washes that let the wood grain show through, and he intentionally did not take pains to hide the checks and cracks that formed as the wood dried. As critic Nell Joslin pointed out, Trotman ". . . likens this imperative in his sculptures—his attempt to show us that they aren't real while at the same time getting us

to believe them—to bunraku, the traditional Japanese puppetry [form in which] puppeteers appear onstage with the puppets. Illusion is achieved in plain view. Trotman says, 'It is like there is a tipping point between reality and imagination, and it is totally delicious to feel yourself go over.'"[24]

Nineteenth-century folk and popular art was another major influence. "Working mostly in wood," he wrote, "I see my efforts in relation to the vernacular traditions of the carved religious figures, ships' figureheads, and the so-called show-figures found in the nineteenth century outside shops and in circuses."[25] Such figures were made to serve purposes beyond the merely decorative, such as encouraging a particular belief, daring sailors to perform acts of maritime courage, or selling tickets and cigars. Each came freighted with a point of view and a whole religious faith or commercial empire, but they all also took advantage of a great shared vocabulary. Their realism, their direct references to the visual world, and their near-human scale made them accessible to anyone. Trotman tapped into that same system of artistic conventions. "A trucker, farmer, or UPS delivery man could see one of my pieces and still 'get' it. You don't have to have to take a college course to find out what it means."[26]

Trotman understood that challenging the corporate world that his parents, and especially his father, represented by pitting vaguely old-fashioned-looking wooden sculptures against it was inherently absurd, but the effort derives much of its power from the quixotic nature of the quest. In this, the examples of anti-establishment artists like Banksy, William Kentridge, George Tooker, and to an extent, Edward Hopper, led the way. As he put it:

[As] a contemporary artist I am fascinated by a noir narrative of life at the office. My wooden people, often surprisingly posed, evoke both humor and anxiety and, taken together, offer an absurdist vision of an imaginary corporate purgatory.[27]

and

I'm trying to look at American capitalism, working with literary sources like [Arthur Miller's] *Death of a Salesman*, dystopian examinations of the business world, and also the fact that that my parents would have liked for me to be one of them.[28]

In each exhibition since 2000, Trotman has slowly expanded the cast of characters he uses to poke serious fun at the corporate world. The original version of his exhibition *Business As Usual* (2008–9)[29] featured three groups of figures enacting independent but interrelated tableaux. *Committee* (2004–5) included four head-and-shoulders portrait busts mounted on pedestals.[30] Different versions of their eyes and mouths were carved on double-ended inserts that could be pulled out like drawers and flipped around to change their expressions, making them, in effect, almost like static puppets. As many as sixty-four different versions of the piece were possible, with members of the group looking adamant, angry, bored, and so on, depending on which facial features were visible. That this was determined by whoever set up the installation underscored the figures as under the control of forces beyond their own. Lacking arms and legs, they were stuck; rather than gathering as a committee to make any decisions, they would have to accept the decisions made for them.

Four figures standing back to back and shrouded under a tarp formed a second piece, entitled *Cover Up* (2008). As anti-busts (with faces and bodies obscured and only legs and feet showing), they communicated a feeling of uncertainty. In the scene that inspired the piece, taken from Sergei Eisenstein's 1925 silent film, *Battleship Potemkin*, the figures under the canvas were Russian sailors, about to be executed for refusing to eat rotten meat. But here the conservative, businesslike footwear confuses and expands the potential meanings. Are they being punished, or are they willfully blind? Are they hiding something, or hiding *from* something? The lack of resolution lends the carving an uneasy energy.

The third piece in that show, *Chorus* (2008), consisted of four more figures, this time depicted from the chest up, with tense, wide-eyed faces, and hands and arms raised skyward. Like Bernini's soul in Hell, they are animated by the ambiguity of their expressions. Arranged directly on the floor, they look equally as if they could be mired in quicksand or else be rising up from the dead. Are they shouting warnings, imploring a higher up for some kind of salvation, or crying out in ecstasy?

When the financial calamity of 2008 coincided with the exhibition, many viewers could not help but interpret *Chorus* as a deliberate commentary on it, seeing the figures as sinking in financial debt. Trotman was quick to deny that this was his intention, pointing out that each of the carvings involved many months in the making, and that the show first opened in the spring of that year, whereas the subprime mortgage crisis hit Wall Street during the first week of September.

This wasn't the first time he had encountered such a situation. His 2001 sculpture *Swan Dive* depicts a businessman standing on tiptoe on the lip of a precipice with arms outstretched. Although inspired by the Yves Klein photo-

montage mentioned above,[31] audiences often linked it to the horrific images of business people jumping from the Twin Towers during the 9/11 disaster: "My sculptures are often seen in the changing light of current events even though they were often made before the events happened. I try to make the images ambiguous enough that they can withstand this, or even gain from it."[32]

Exhibitions following *Business As Usual*, including *Inverted Utopias* (2010-2011, North Carolina Museum of Art), *Connections* (2011, Huntsville Museum of Art) and *Office* (2012, Morris Museum of Art), continued to explore various takes on the corporate world as a phenomenon worthy of representation in art. Along the way, additional works joined the ensemble as Trotman developed his skills and continued to carve. According to critic Nell

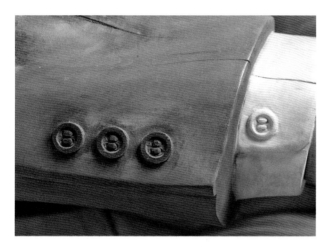

Joslin, "These figures owe some of their verisimilitude to Trotman's years as a furniture maker. The way the pieces of each sculpture fit together, how the unusual poses are balanced and stabilized as a practical matter, and the beauty of the finishes mark his passage through furniture-making . . . which earned him a national reputation and a cachet among collectors."[33]

A 2010 piece commissioned by the North Carolina Museum of Art, entitled *Vertigo,* marked the first time that Trotman implicated himself by creating a caricatured self-portrait in business attire. The larger-than-life figure, which weighs some 500 pounds, is depicted in free fall without a parachute (the sculpture is suspended by cables). With its tie fluttering over one shoulder and oversized hands outstretched and flapping vainly against the onrush of air, the figure embodies the multiple meanings and possible readings that had gradually become the hallmark of Trotman's mature style.

In his own interpretation, "There is the suggestion of the brutal, brutish side of unregulated American capitalism (markets driven by greed and panic; competition spurred by survival of the fittest) and the unavoidable echo of 9/11, elements that are purposefully entwined rather than resolved. The figure bears a caricature of my own head, but in this frozen moment, the illusion of stability has been stripped away. With vertigo only the possible remains."[34]

Although Trotman refers to the piece as capturing or occurring in a "frozen moment," *Vertigo* approaches terminal velocity in the mind of the viewer, who can't help but envision the next frame and the one after it as the figure falls toward some unknown fate. That fate might be realized in the next few seconds or it might never arrive at all. This gave the figure a detached, almost kinetic energy that marked a new stage in Trotman's development. Some earlier pieces, like *Janet (Free Fall)* (2001), *Girl* (2002), and *Uta* (2008), had also featured falling figures—Trotman's challenge to sculpture's age-old tradition of heroes standing triumphantly (if absurdly) secure atop their pedestals—but these figures are already in contact with the ground, which diminishes the range of possible outcomes, or at least the range of dire impacts those outcomes might have been. Even though their balance seems precarious, they could merely have been spinning on their heads while breakdancing, for example. But the figure in *Vertigo*, despite his inane expression and the visible cables suspending it, could very well be on his way to doom. As with the bunraku puppetry mentioned above, the illusion isn't spoiled by seeing how it was achieved.

"People like to be reminded that they're being fooled. Just like they admire the televangelist who preaches about charity, but pulls up in a limousine wearing expensive snakeskin boots. They know the politician is a conman, but are even more willing to vote for him the more he makes it obvious. It is probably easier to identify with the person exercising power over you if you can see how the act was performed. Then you can say, 'There goes me, if only I had done the same thing he did.'"[35]

Trotman's latest works take advantage of the principle of obvious trickery more than ever. Several pieces in this second manifestation of *Business As Usual* make almost no effort to conceal the ways they were constructed or how they function, and reveal a much greater willingness to rely openly on electronic or kinetic effects to animate them. For example, walking around the reverse side of *Trumpeter* (2014), a figure whose business-suited body terminates in a fiberglass megaphone spewing recorded nonsense, one easily sees how the wood was hollowed out to make the figure, with its sound-generating apparatus in plain view.

In several other pieces, like *Shaker* (2013), a revolving bust with one hand outstretched to offer a handshake, and *White Man* (2016), a resin-cast molded figure of a businessman with his chest preposterously outthurst, the hollow backside equally visible. Trotman considers this integral to the meanings of these pieces: the false fronts these figures show the world aren't backed up with anything of real substance. They are, to use T. S. Eliot's term, literally "hollow men."

Capitulation Device (2014) waves a small white flag of surrender with the regularity of a metronome or windshield wiper, but the little cam-and-lever contrivance that makes this happen could hardly be simpler or more upfront. The fact that the flag is mechanized at all, however, hints that surrender is an ongoing, oft repeated, and endlessly tiresome chore. If it were a one-time thing, a handheld hanky would have sufficed.

In *Clicker* (2014), another simple mechanism is showcased: a big-toothed cog that emits a sharp ticking sound as it slowly ratchets around. The sheer obviousness of the apparatus somehow doesn't rob it of its oppressive effect or downplay the seriousness of its messages. With each loud click, it seems to say, "Time is passing; time is money; time is *not* on your side," while other ominous associations, like time bombs, punch clocks, Poe's "Telltale Heart," the clock without hands in Ingmar Bergman's *Wild Strawberries*, and the pocket watch of the condemned man in Ambrose Bierce's "An Occurrence at Owl Creek Bridge," are there, too, and not unintentionally. Life is time, and it is a good idea not to waste it.

Waiter (2014) deals with time as well but with menacing overtones projecting dominant male power. A huge, masculine hand, wearing the kind of heavy gold signet ring that bourgeois executives favored during the *Mad Men* era, impatiently taps the table it rests upon with its big index finger. The ring is engraved with the letters VIP, lending a subtle humor to the effect, for any truly Important Person wouldn't have thought it necessary to announce the fact. A related piece, *Me Ring* (2015), is even more blatant in mocking that kind of self-importance. A giant golden ring emblazoned "ME" revolves on a tawdry pedestal that resembles a third-rate magician's prop. The tackiness of the display undercuts the projection of power that such a ring would have been intended to convey. Here again, the message of the piece probes the hollow pretense of a power that would insist so openly on its privilege of being seen and acknowledged.

In some of the artist's other recent pieces, the intentionally prankish obviousness is not achieved by exposing the mechanism so much as by embedding it in their titles. *Safe Sex* (2016), for example, is a play on words: a businessman stands behind a sturdy combination safe, mechanically thrusting his pelvis against it with lips tightly pursed. *Clubman* (2012) also offers a visual pun by playing the archetypal business-suited country-club "type" off the classic Stone Age club clenched in his fist. The phallic weapon—a symbol used to ridicule male dominance in comics and cartoons since the eighteenth century, but also resonant with a kind of Lester Maddox brutishness—ultimately expresses timid fear far more than power, as does the figure's reduced size. Both he and the diminutive *Senior Partner* (2014), a suited businesswoman with her arms locked over her breasts, must tilt their heads back to stare up at the viewer, while their small size reflects the state of their souls. Meanwhile, *Fountain* (2014) spoofs "trickledown economics" with an anthropomorphic combination safe outfitted with a faucet and bucket that circulates a suggestively golden liquid. This time the safe *is* the suit, but the man inside seems more trapped than protected.

Bob Trotman has clearly hit his stride, and he seems to be having a fine time turning one aspect of the corporate world after another into sources for new work. After all, it is a vast domain, and relatively few artists have prospected, much less mined it. "Now I'm putting my father to work for me," he says, "as inspiration." The initial impetus provided by his upbringing and the rejection of his parents' aspirations is no longer the major motivation, for he is already well beyond the point that any wounds or accumulated slights inflicted by either of them can hurt him. Now he is exorcising his own demons. "I have been so much worse to myself than my parents ever were. They lived in a world where wealth proved success, whereas to me, failure feels rich, if it comes from attempting something I haven't tried before. Right now, capitalism is giving me plenty to think about, but if I ever get tired of that, there are lots of other things to work with. Like politics. But right now I'm having too much fun to quit."[36]

Roger Manley
Director/Curator
Gregg Museum of Art & Design
NC State University

Notes

1. Winston and Salem consolidated in 1913, the same year that R. J. Reynolds introduced Camel, the first cigarette to come pre-rolled in a pack (previously, smoking tobacco had been sold loose in a bag, along with rolling papers).

2. From an oral-history interview between Roger Manley and Bob Trotman, March 9, 2017.

3. In old Salem, failure to abide by the rules or decisions of the elders could result in banishment from the community. The elders were immanently pragmatic, sometimes almost ruthlessly so. The church opposed whippings, but when a site was needed for the new courthouse, they sold the land to build it, a mile north of the village. Punishments could then take place on the new, and secular, courthouse grounds, where the cries of the condemned would be out of earshot.

4. Carla Hanzal, from an interview she conducted for the Archives of American Art's Nanette L. Laitman Documentation Project For Craft and Decorative Arts in America, September 14, 2005, 7.

5. Ibid.

6. From an oral-history interview between Roger Manley and Bob Trotman, March 10, 2017. The image is a photomontage by Harry Shunk and János Kender, made in October, 1960. Unfortunately, the ease with which digital management programs like Photoshop now make it possible for nearly anyone to create such images has greatly diminished our appreciation for the startling impact this one had at the time. Trotman would later turn to this image as inspiration for works like Swan Dive (2000) and Vertigo (2010).

7. Karl Marx, Kritik des Gothaer Programms, 1875.

8. Elliott Wigginton, ed., The Foxfire Book: Hog Dressing, Log Cabin Building, Mountain Crafts and Foods, Planting by the Signs, Snake Lore, Hunting Tales, Faith Healing, Moonshining, and Other Affairs of Plain Living (New York: Anchor, 1972), was the first in a series of fourteen books written mostly by students at the Rabun Gap-Nacoochee School in northeastern Georgia, a region very much like the one where Trotman lives. Chapters consisted of how-to instructions ranging from hog-butchering to basketry and gunsmithing.

9. Hanzal, 11.

10. Ibid., 13.

11. Ibid., 37.

12. As Edward S. Cooke, Jr., of Yale's Department of the History of Art has pointed out, the terminology of furniture already suggests its anthropomorphic qualities: ". . . chairs have feet, ankles, knees, backs and ears; tables have legs, skirts or aprons . . ." (personal correspondence between Cooke and Charlotte Wainwright, retired director of the Gregg Museum of Art & Design, December 22, 1993). The famous fixtures in the beast's chateau in Jean Cocteau's 1946 film La Belle et la Bête further illustrate the ease with which furniture lends itself to anthropomorphic metaphors.

13. From interviews between Mark Richard Leach and Bob Trotman, August 3 and October 3, 1995, for the Mint Museum, Charlotte, NC.

14. Ibid.

15. From an interview between Jan Brooks Loyd and Bob Trotman for N.C. State University's Gallery of Art & Design (now the Gregg Museum), ca. 1993.

16. Hanzal, 6.

17. Manley interview, March 10, 2017.

18. Hanzal, 23.

19. Rough draft of a narrative for an artist residency application by Trotman, n.d.

20. In Book Four of Milton's Paradise Lost, angels find the Devil squatting ". . . like a Toad, close at the eare of Eve." The First Six Books of Milton's Paradise Lost, Edinburgh: A. Kincaid, W. Creech and J. Balfour, 1773, page 295, line 800.

21. The argument has been made, in fact, that it doesn't depict a soul in hell at all but a satyr, and was only identified as a suffering soul to keep papal authorities from seizing it. See David García Cueto, Sculpture Journal 24, Issue 1 (January 2015): 37–53.

22. In Act 1, Scene 3, of Hamlet, Polonius says, "Apparel oft proclaims the man," or, as Mark Twain more famously riffed, "Clothes make the man. Naked people have little or no influence on society."

23. Trotman also began to follow the medieval and Renaissance tradition of using additional help, in his case from professional carver David Caldwell, who makes enlarged replicas of Trotman's clay maquettes as roughed-out figures that Trotman later finishes carving and then paints.

24. Nell Joslin, "Illusions in Carved Wood," Raleigh News & Observer (Sunday, May 9, 2004, online edition).

25. Artist's statement, from Trotman's website at http://www.bobtrotman.com/about.

26. Manley interview, op. cit.

27. Artist's statement, n.d.

28. Quoted in http://stateofheart.crystalbridges.org/blog/project/bob-trotman/.

29. It originated at the Staniar Gallery at Washington and Lee University and toured in North Carolina to the Cameron Art Museum, Wilmington, the Greenville County Museum of Art, and the Mint Museum of Art, Charlotte.

30. They are nominally based on people Bob Trotman knows: Tom (Tom Spleth, ceramicist), Stu (Stuart Kestenbaum, poet), John (a lifelong friend), and Jane (his wife). However, he only used them as models because they were comfortable enough to let him caricature them; otherwise, the names and resemblances have no significance.

31. And perhaps also to some degree by George Tooker's 1949 painting, Cornice.

32. Interview between Leigh Dyer and Bob Trotman, in Inspired, the membership magazine of the Mint Museum (February–June 2017), 3.

33. Joslin, op. cit.

34. Bob Trotman, in Linda Johnson Doughtery et al., Bob Trotman: Inverted Utopias, exh. cat. (Raleigh: North Carolina Museum of Art, 2010), 61.

35. Manley interview, op. cit.

36. Ibid.

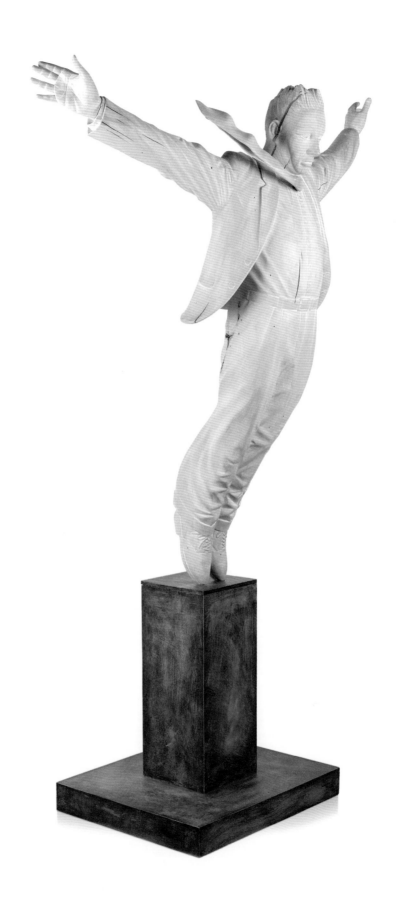

Swan Dive, 2001
Wood, steel, paint
79 x 49 x 27 in.
Collection of Frances and Sydney Lewis
Photo: North Carolina Museum of Art

Sinking Feeling, 2001
Wood, latex, tempera
53 x 34 x 35 in.
Collection of Hedy Fischer and Randy Shull
Photo: North Carolina Museum of Art

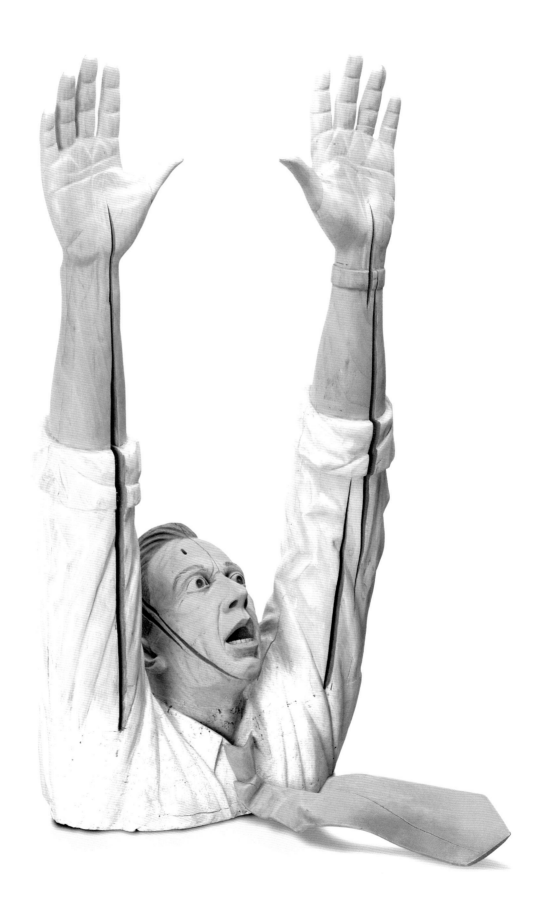

Cake Lady, 2002
Wood and tempera
37 x 19 x 26 in.
Collection of Dana and Rick Davis
Photo: North Carolina Museum of Art

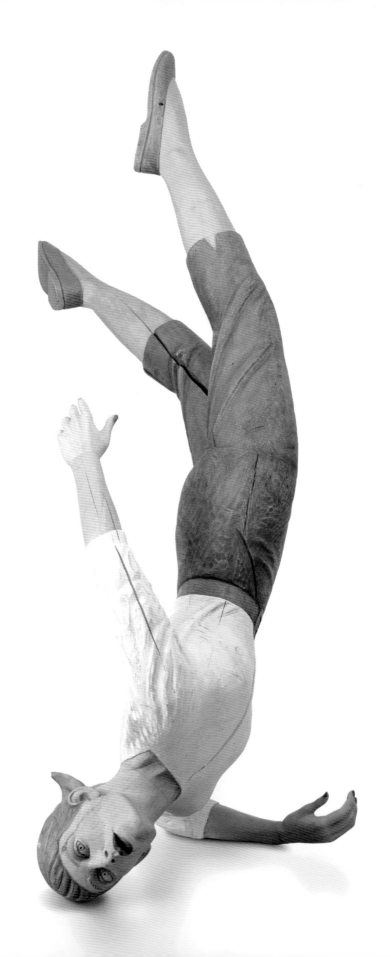

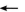

Girl, 2002
Wood and tempera
65 x 49 x 41 in.
Collection of North Carolina Museum of Art, Raleigh, NC
Photo: North Carolina Museum of Art

following pages:
John, 2005
Wood, hardware, tempera
70 x 25 x 17 in.
detail follows

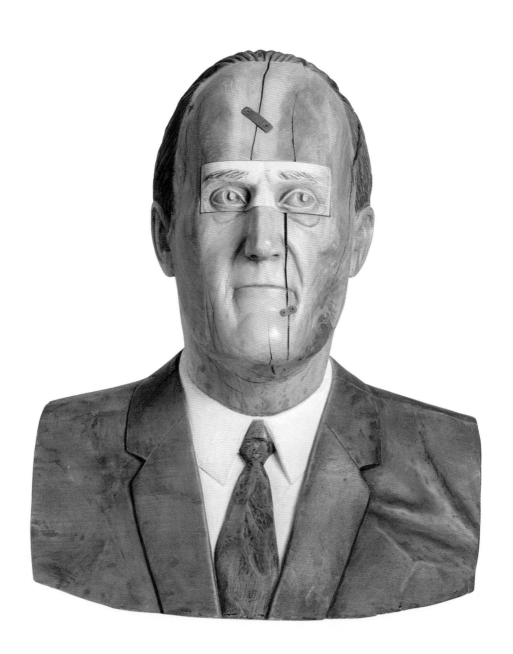

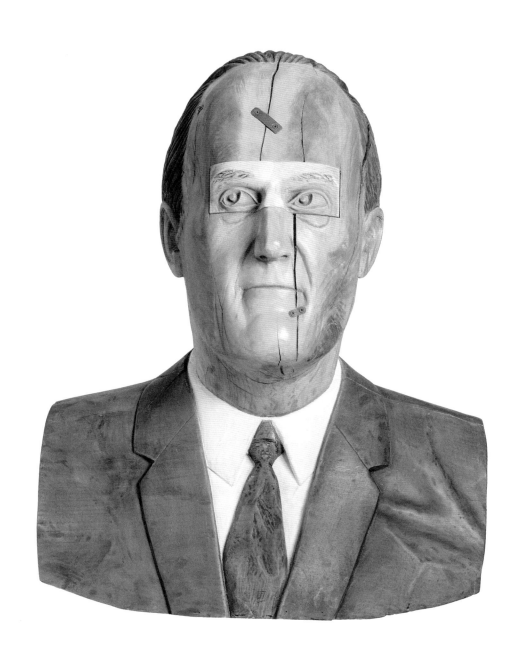

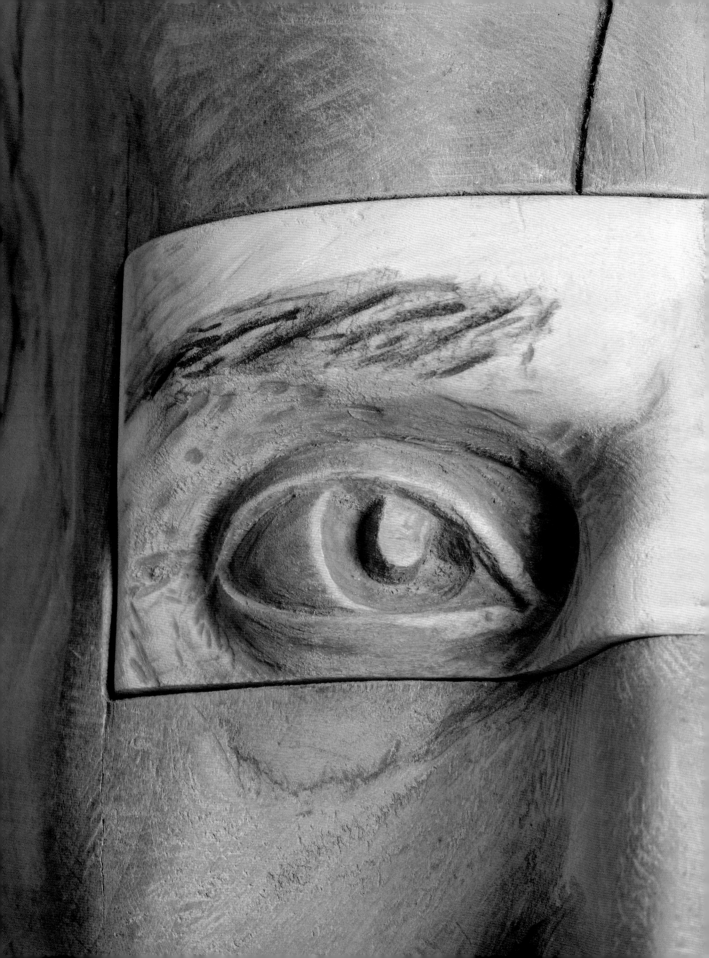

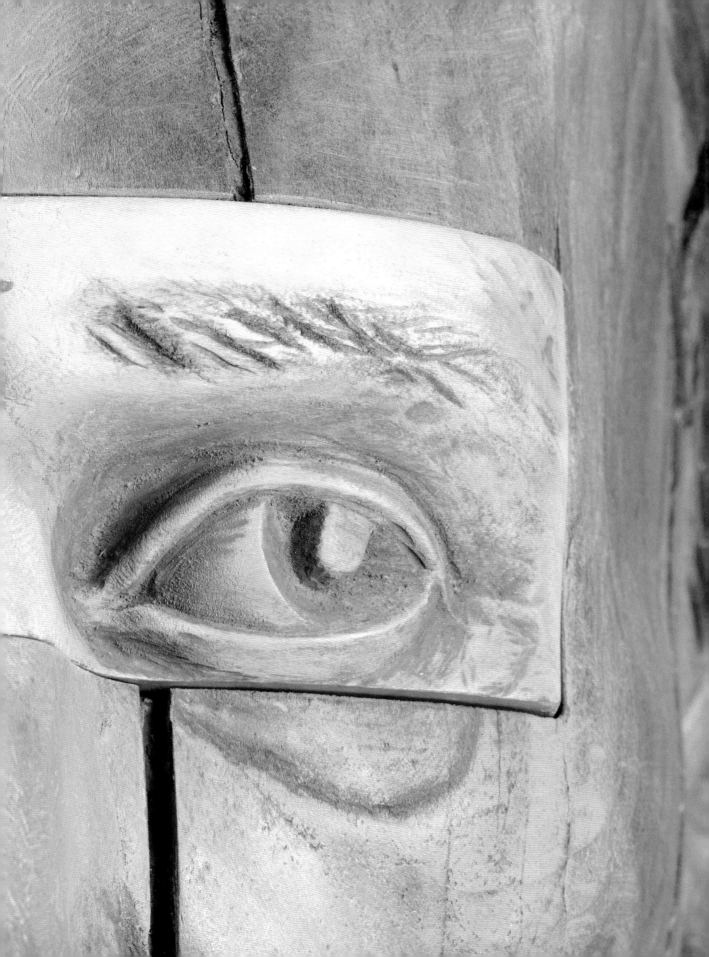

Stu, 2005
Wood, hardware, tempera
70 x 27 x 20 in.
details on following pages

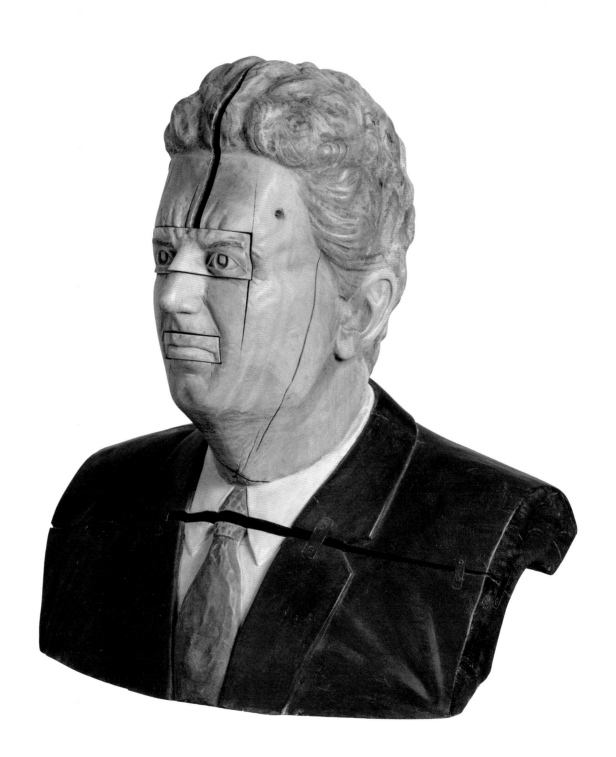

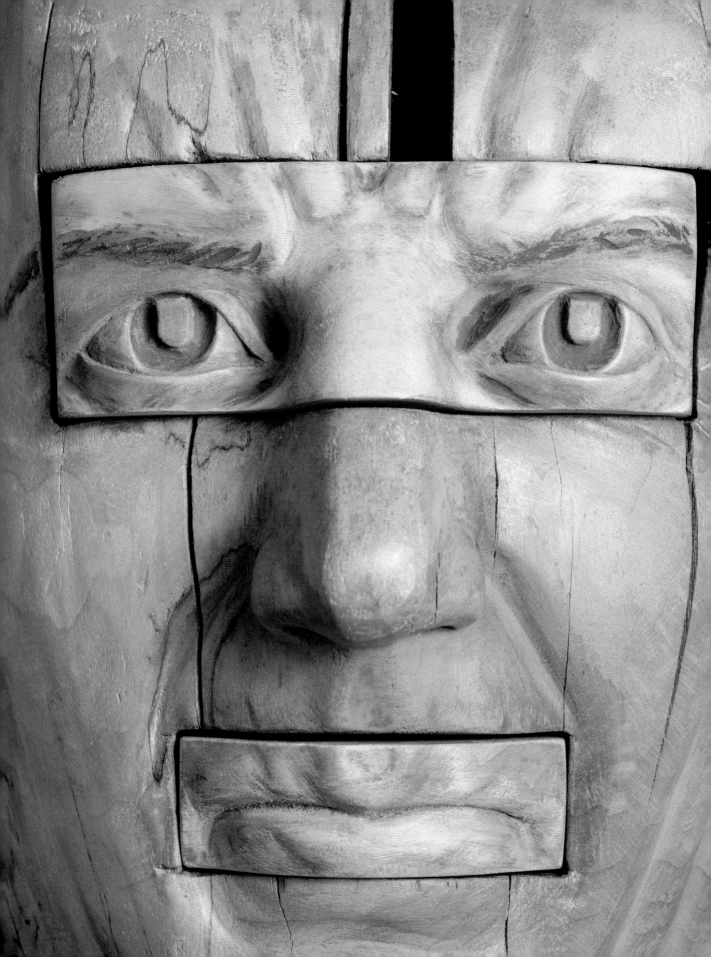

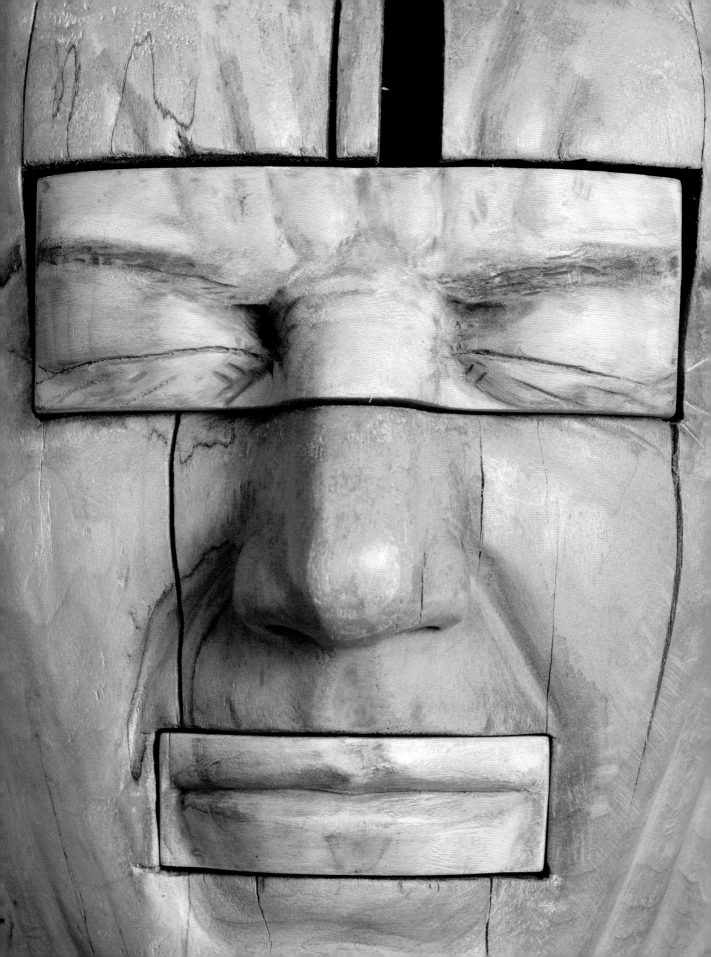

Tom, 2005
Wood, hardware, tempera
70 x 26 x 20 in.

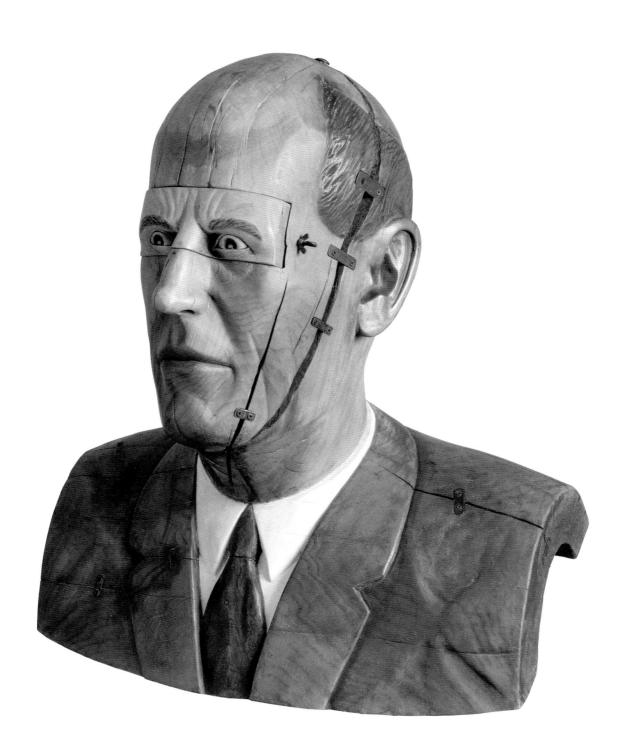

Lisa, 2005
Wood, PVC pipe, hardware, concrete, tempera
70 x 24 x 20 in.
Photo: Kevin Remington

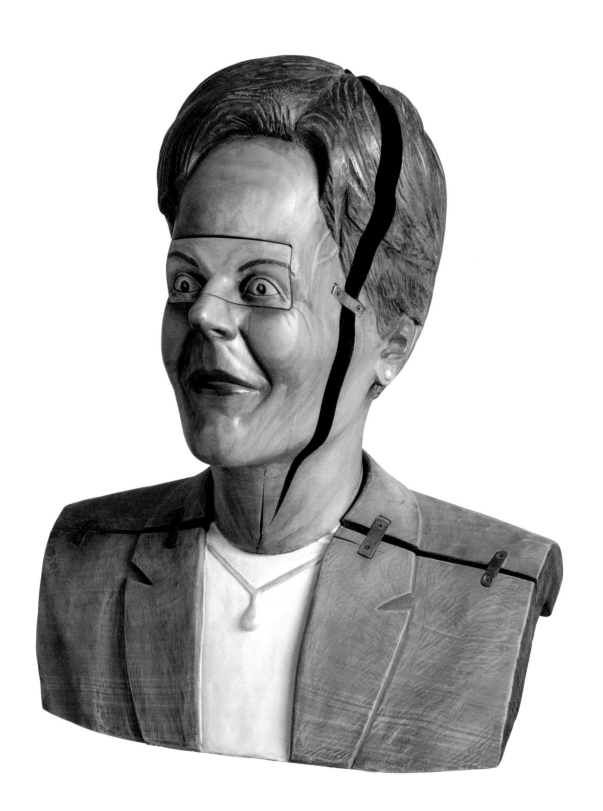

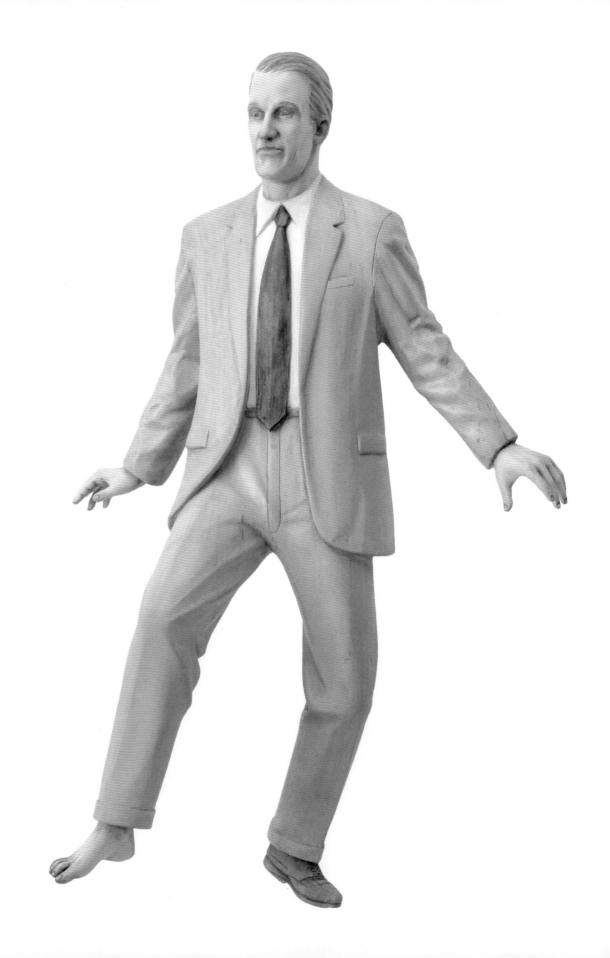

Olive Suit, 2006
Wood, tempera, wax, wall mount
24 x 16 x 9 in.
Collection of Suzanne and Elmar Fetscher

Martin (Kneeling), 2008
Wood and tempera
41 x 23 x 23 in.
Collection of the Mint Museum, Charlotte, NC

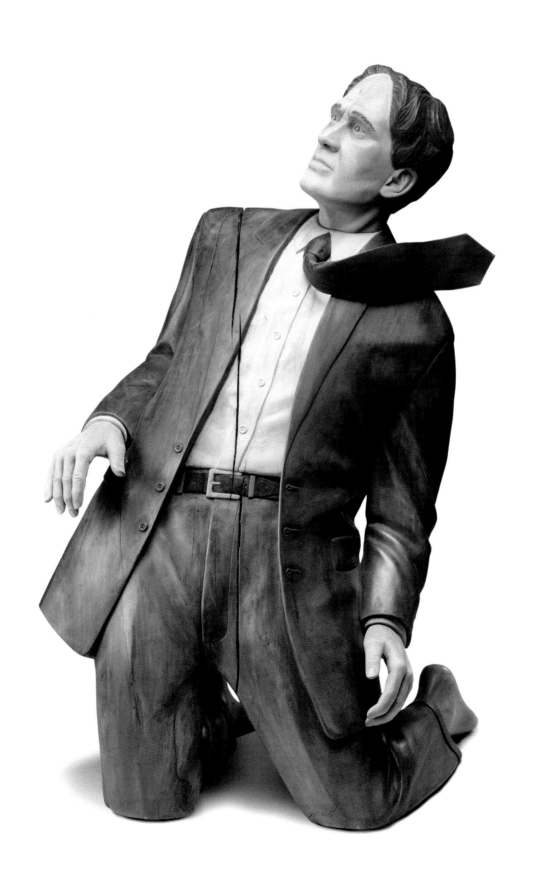

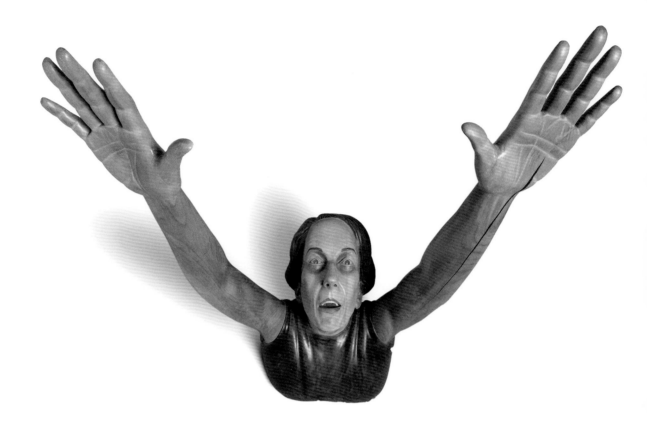

Jane, 2008
Wood, tempera, wax
50 x 39 x 19 in.

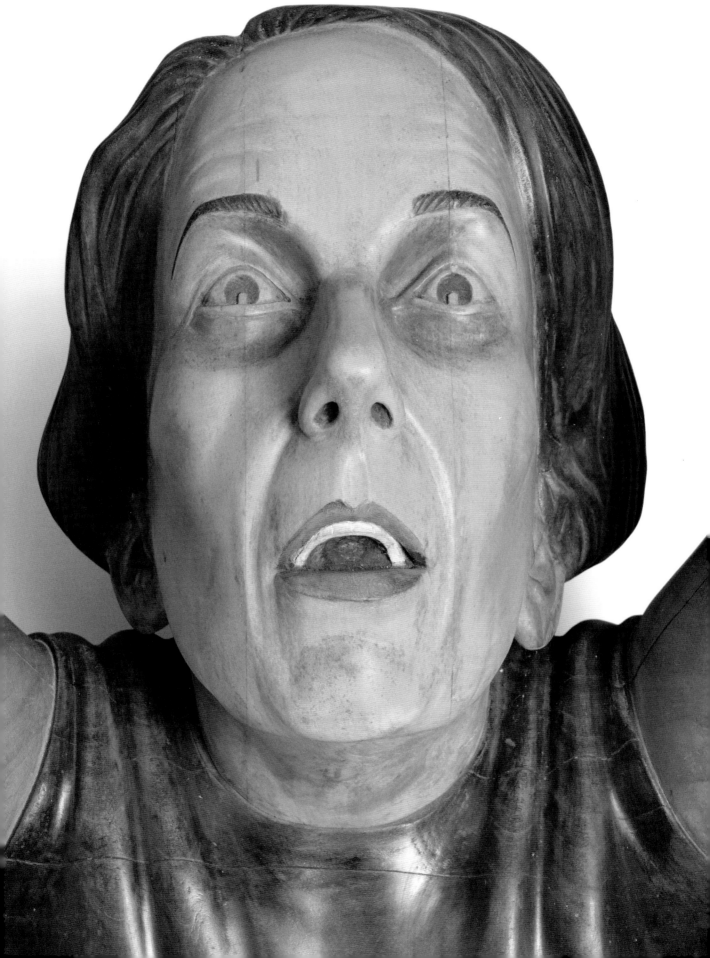

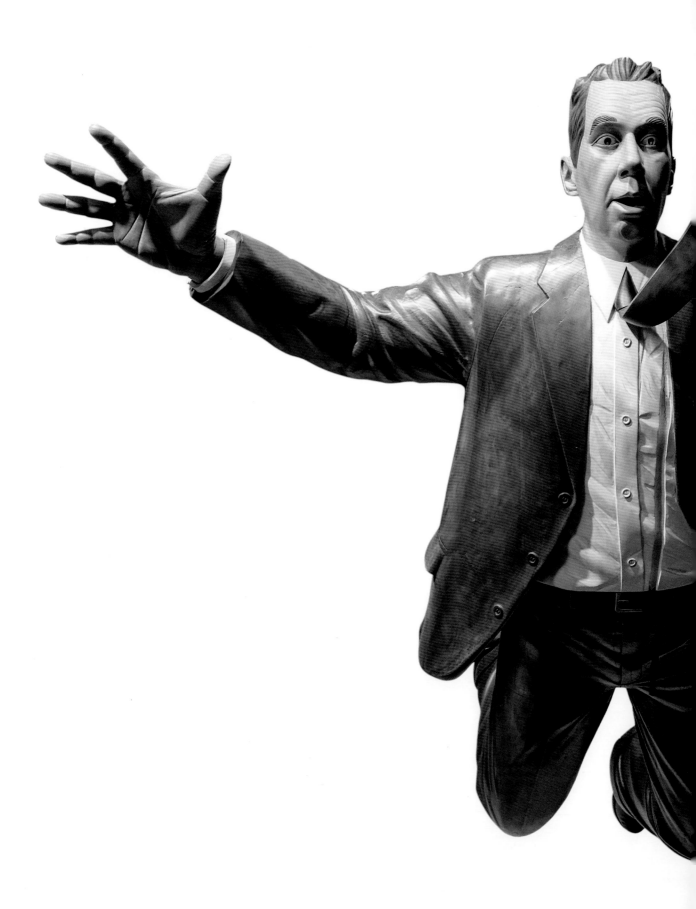

Vertigo, 2010
Wood and tempera
40 x 90 x 88 in.
Collection of North Carolina Museum of Art, Raleigh, NC

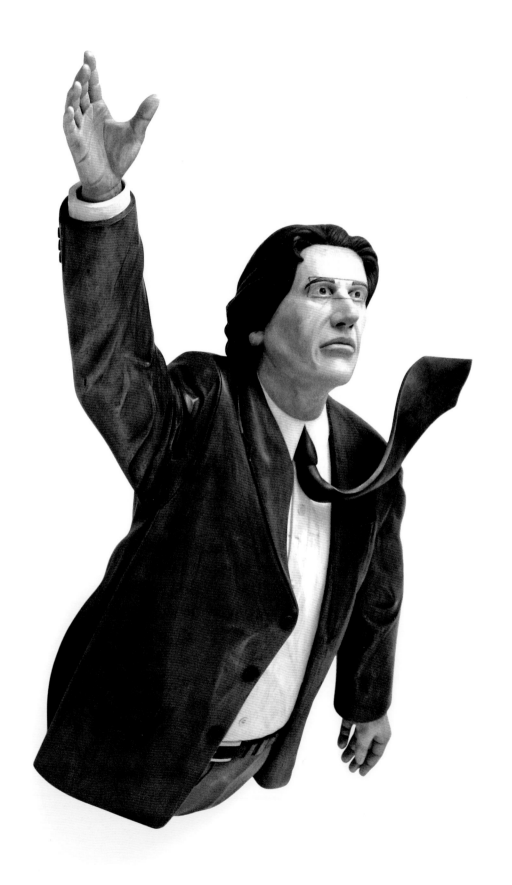

Leading Man, 2010
Wood and tempera
59 x 21 x 44 in.
Collection of Andrea and Robert Maricich

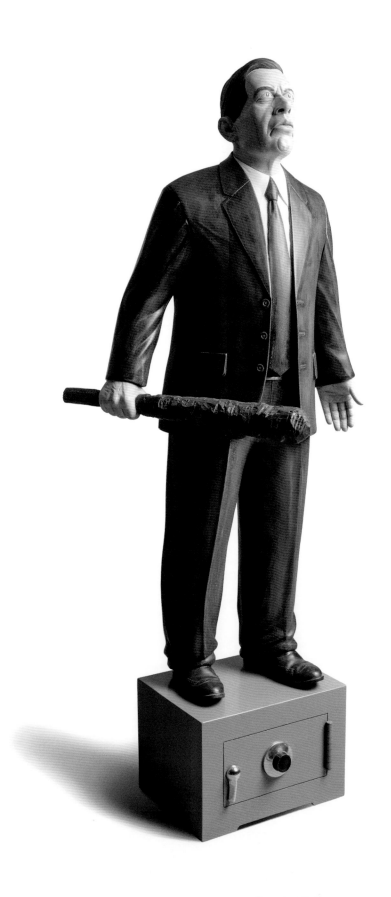

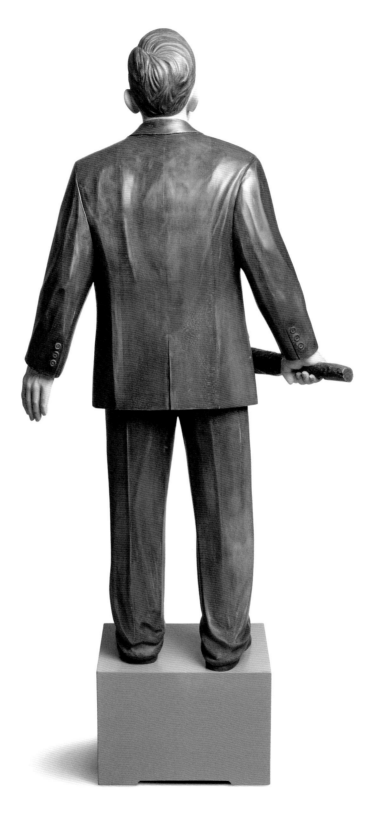

Clubman, 2011
Wood, tempera, wax
59 x 26 x 20 in.
details on following pages

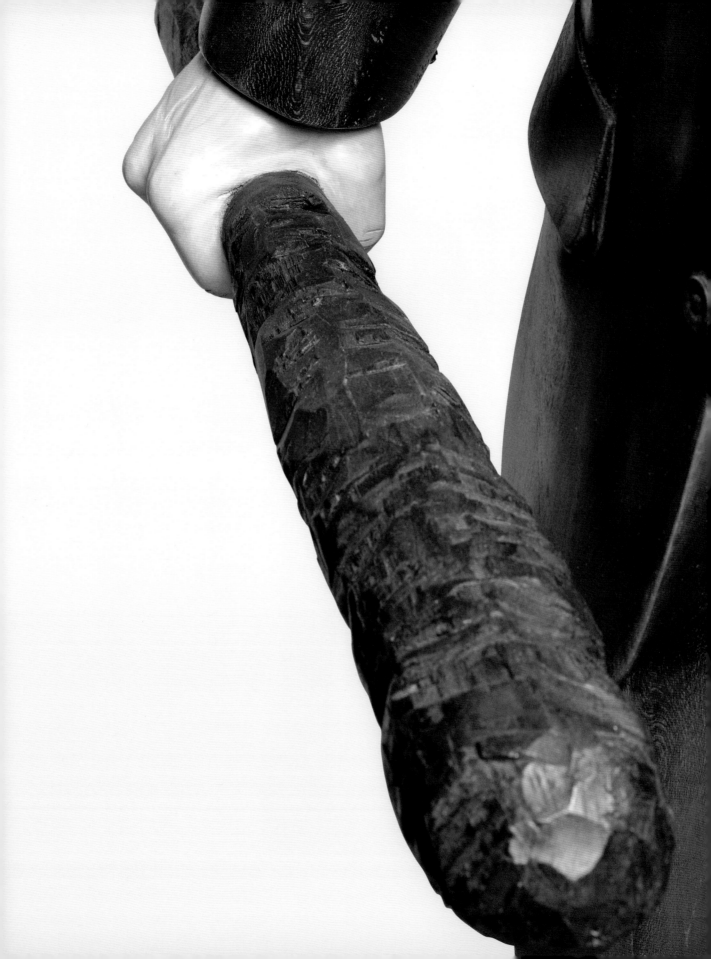

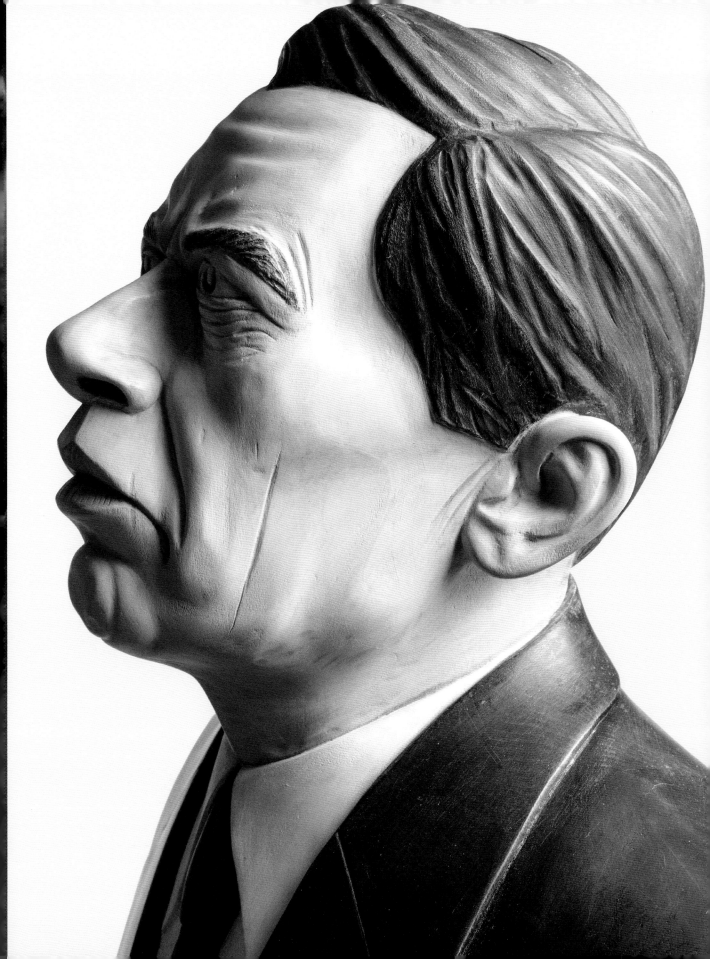

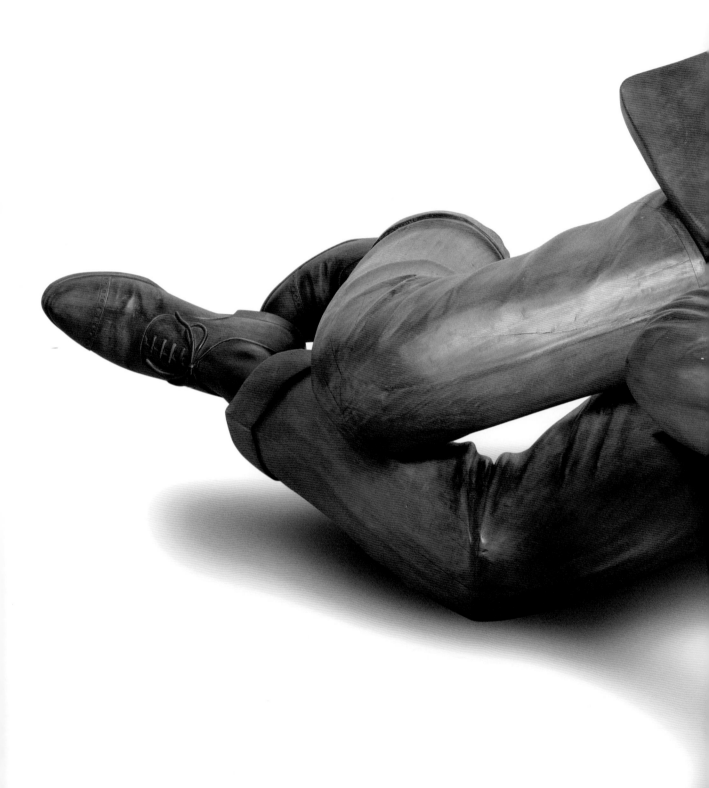

Floor Man, 2011
Carved wood, tempera, wax
28 x 74 x 40 in.

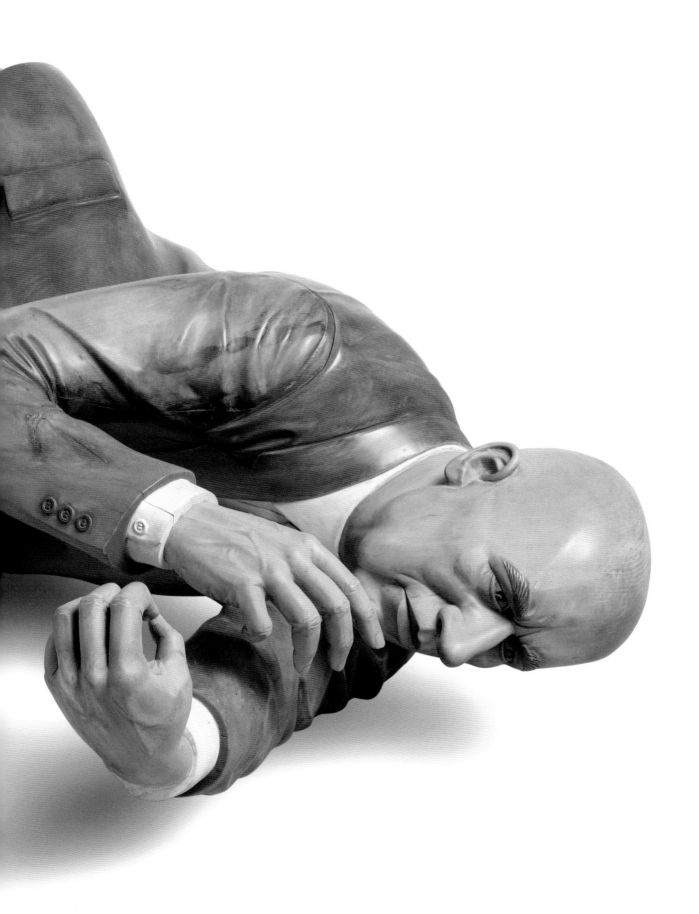

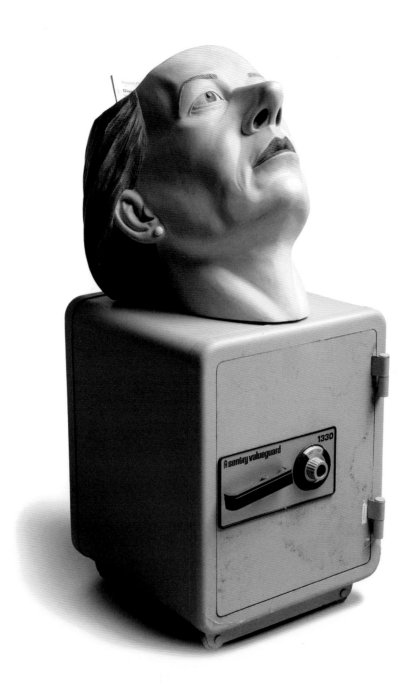

Safe Woman, 2012
Wood, tempera, wax, steel safe
39 x 17 x 17 in.
detail on following pages

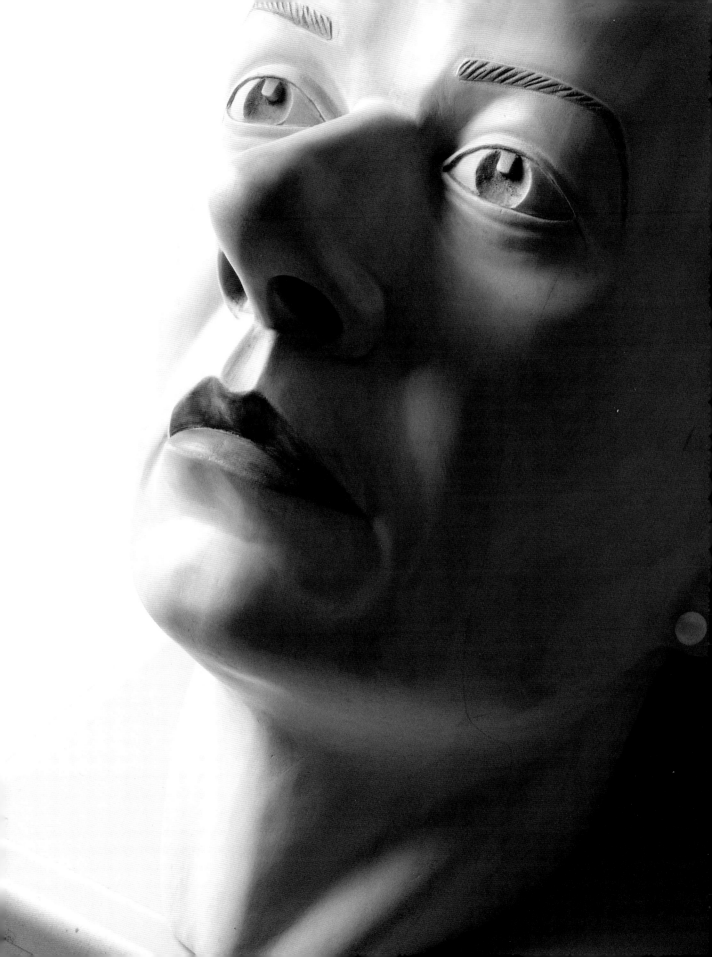

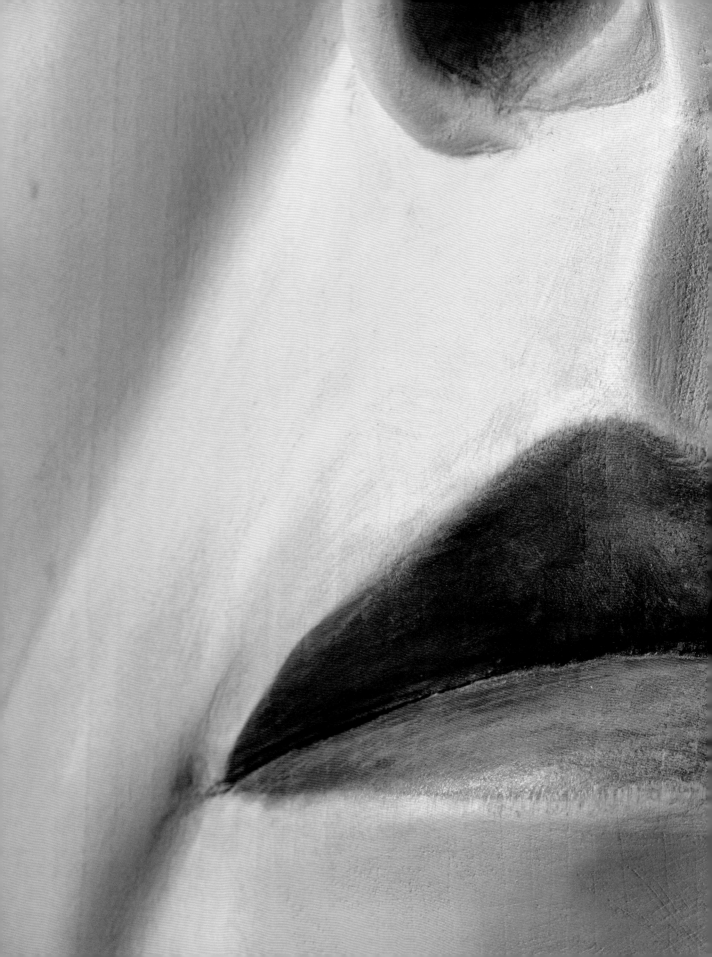

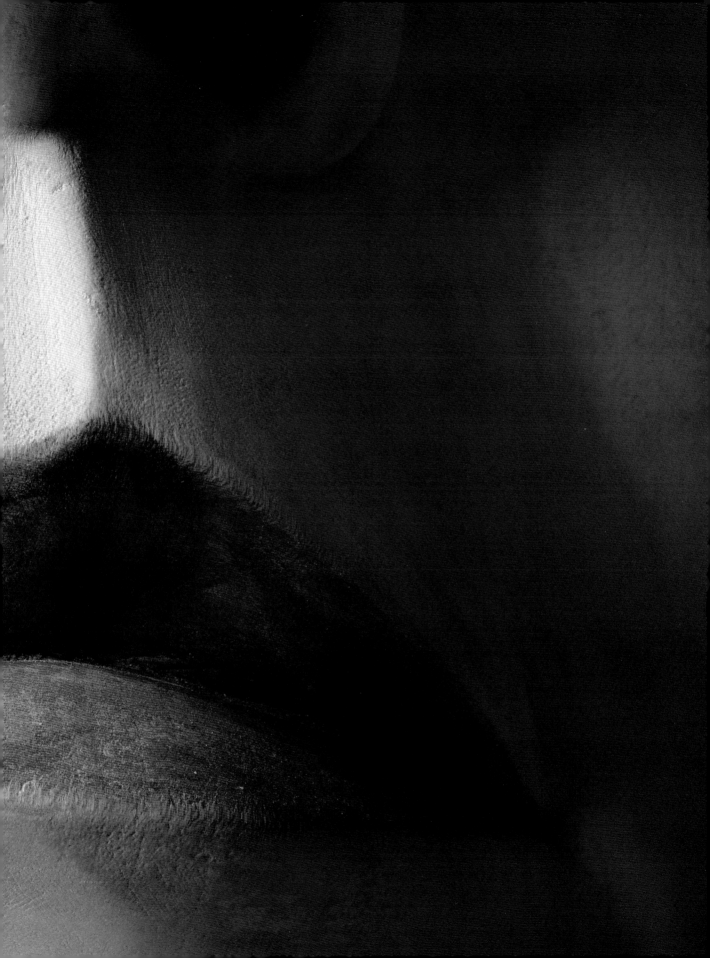

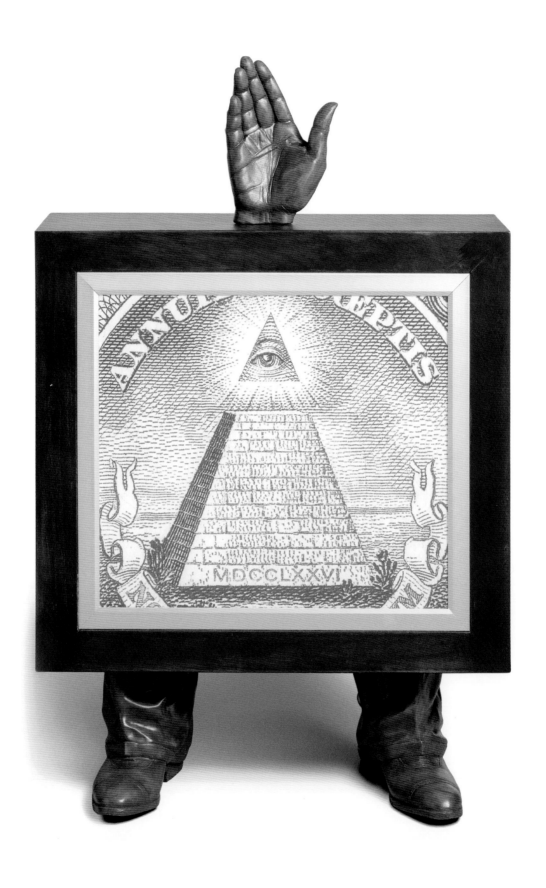

The Ascendency of Desire, 2013
Wood, terra cotta, gold leaf, commercial light
box, photographic transparency
42 x 27 x 14 in.

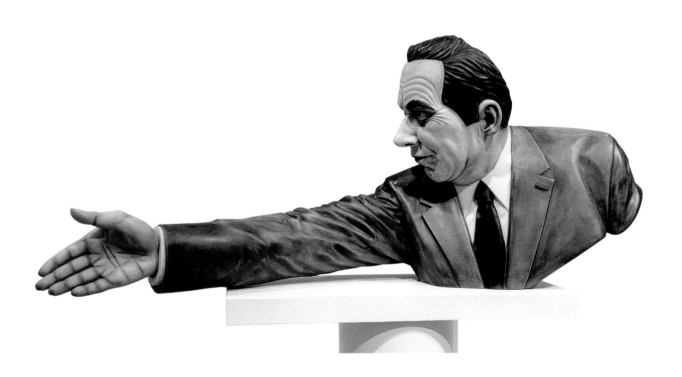

Shaker, 2013
Wood, PVC pipe, motor, tempera, latex, wax
67 x 53 x 28 in.
Collection of Crystal Bridges Museum of American Art, Bentonville, AR
Photo: Halsey Institute of Contemporary Art

Bob Trotman 2012

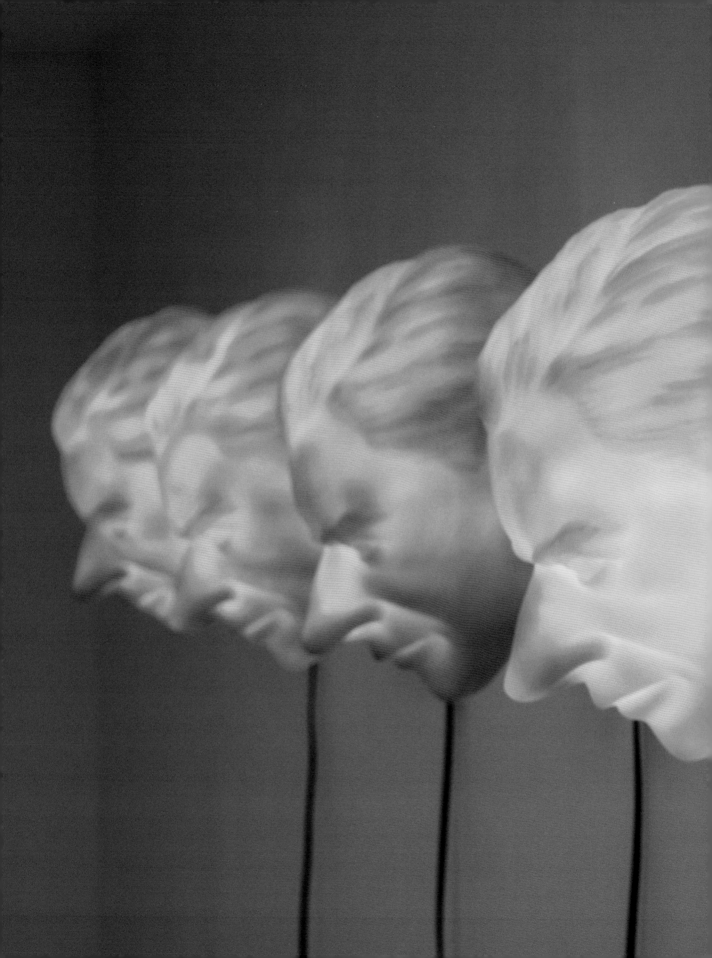

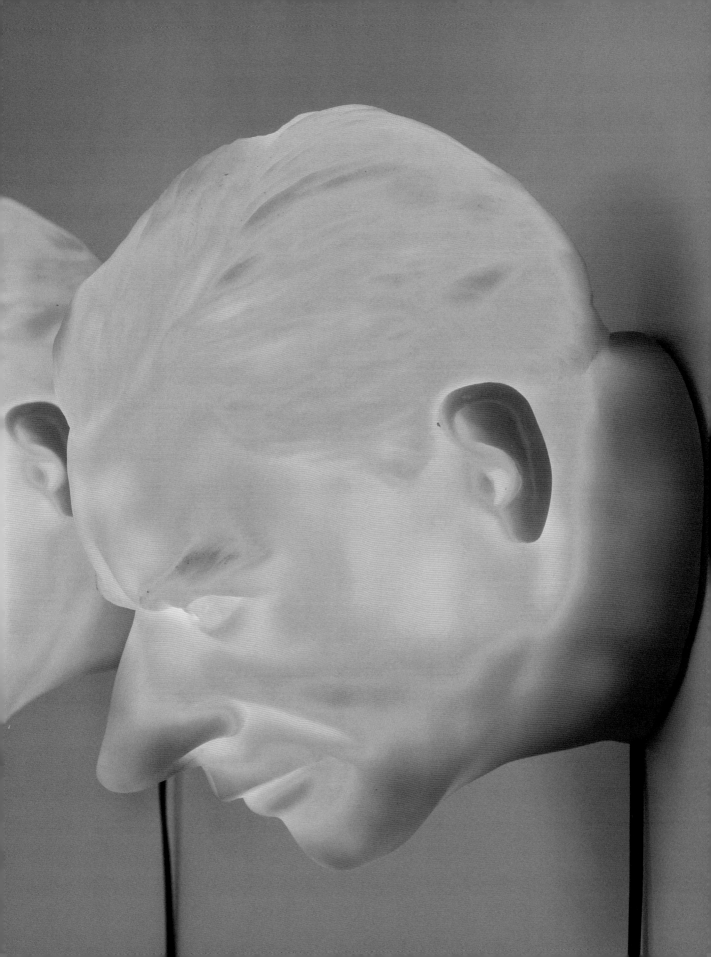

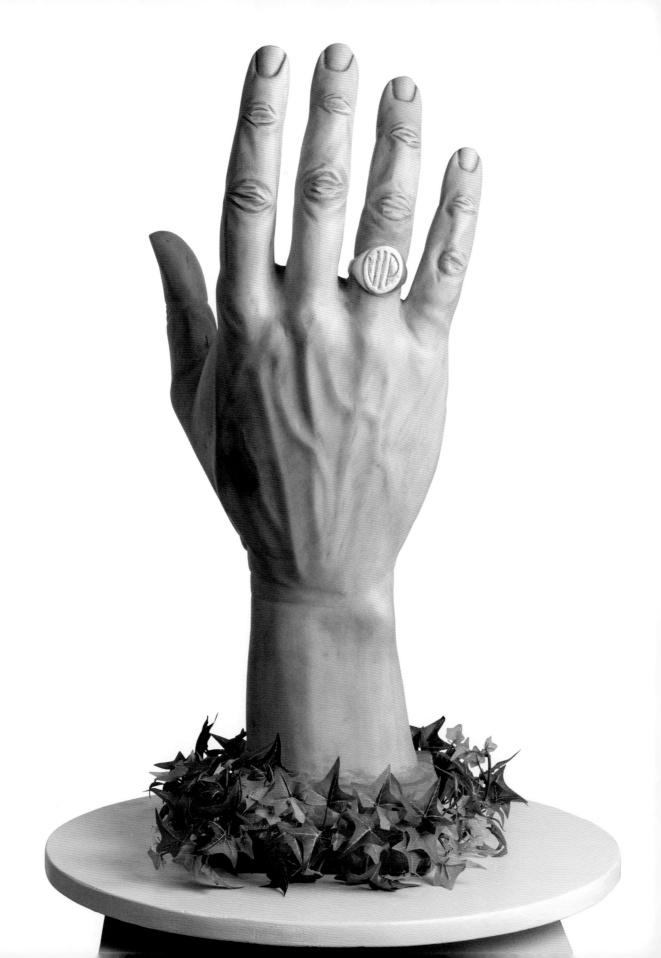

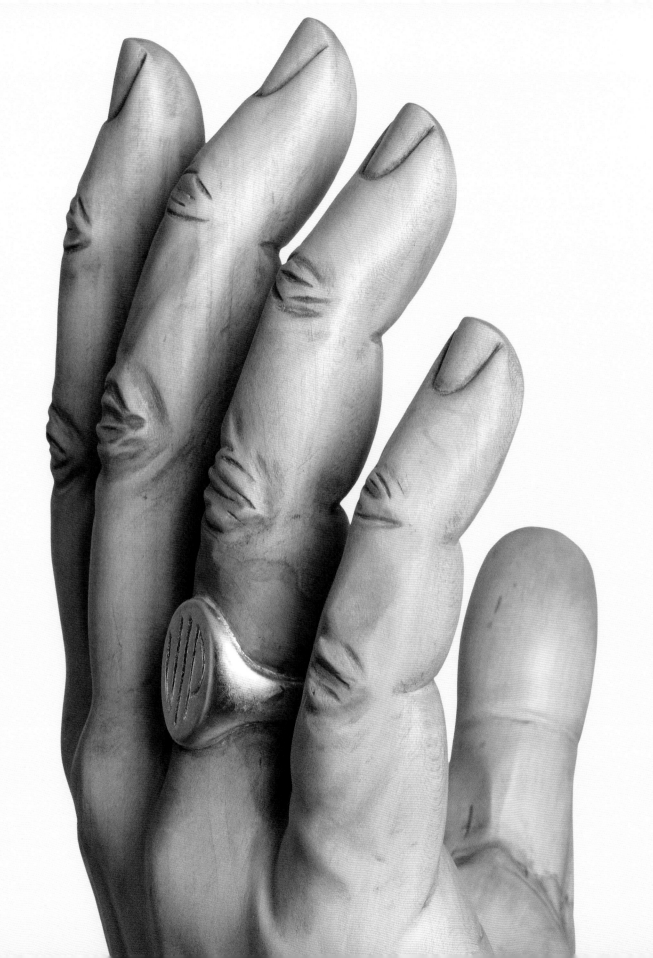

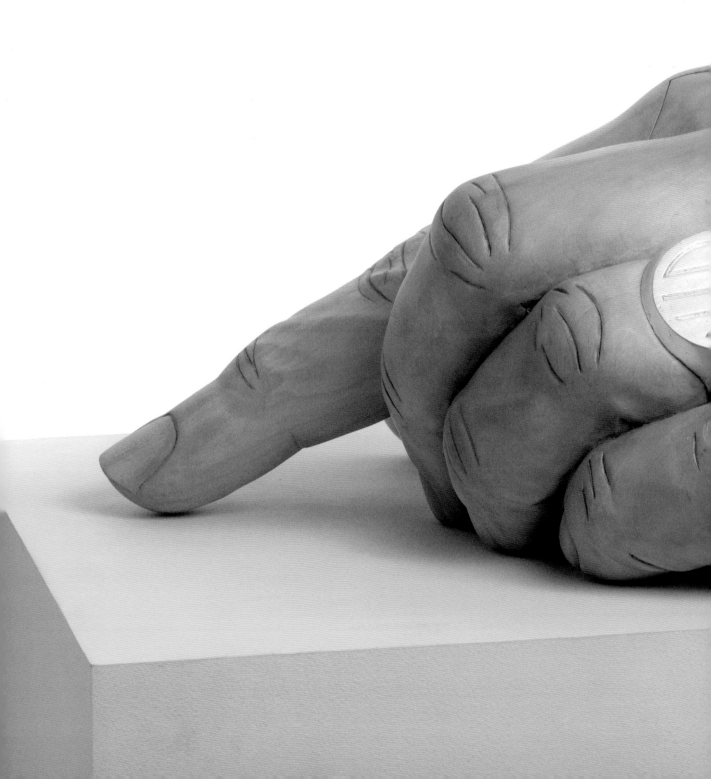

previous pages:
VIP Hand, 2013
Wood, tempera, gold leaf, wax, artificial ivy, motorized turntable
25 x 11.5 x 7.5 in.

Waiter, 2014
Carved wood, gold leaf, motor, tempera
12 x 22 x 28 in.
detail on following pages

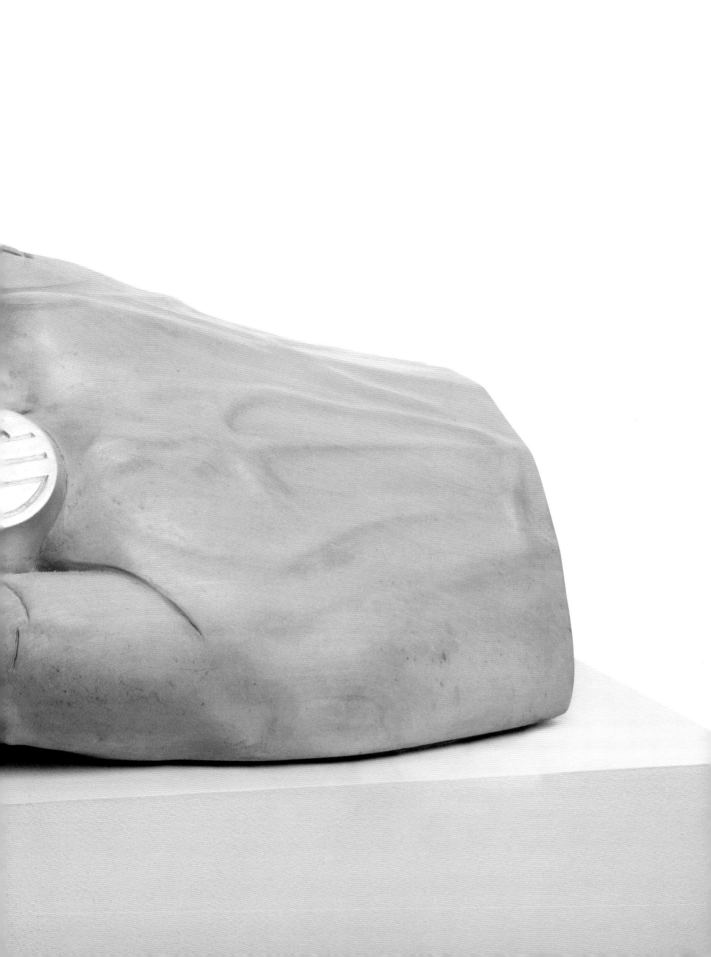

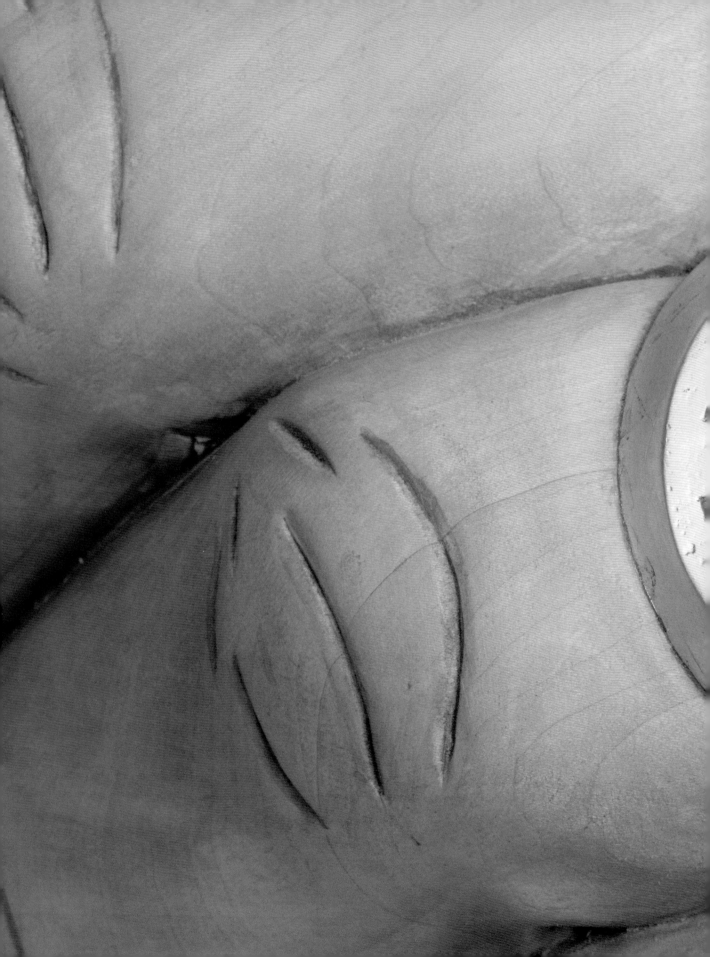

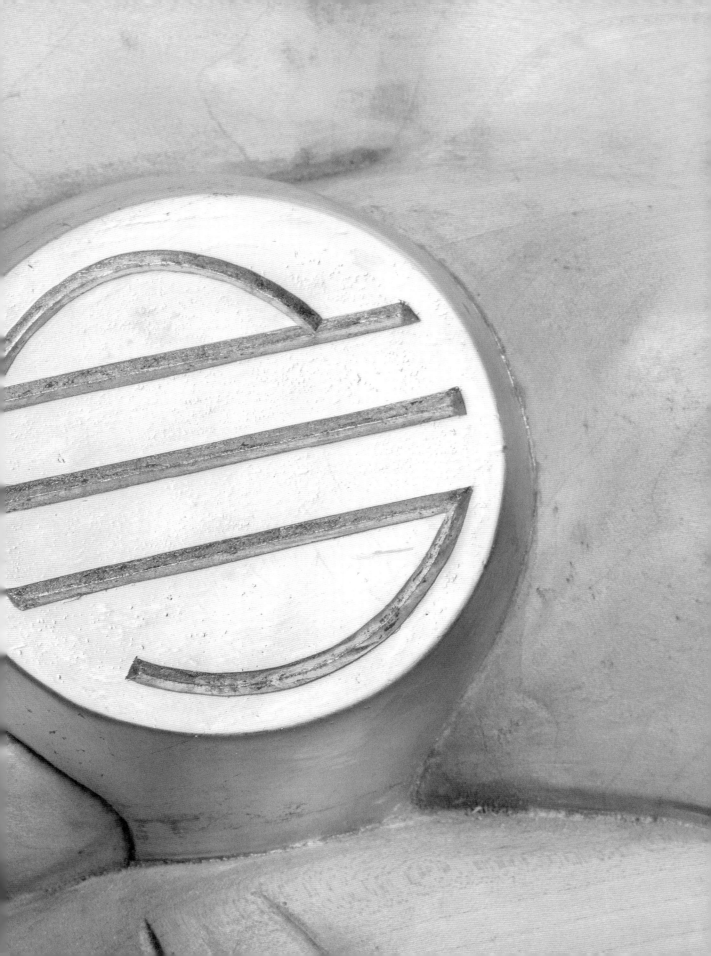

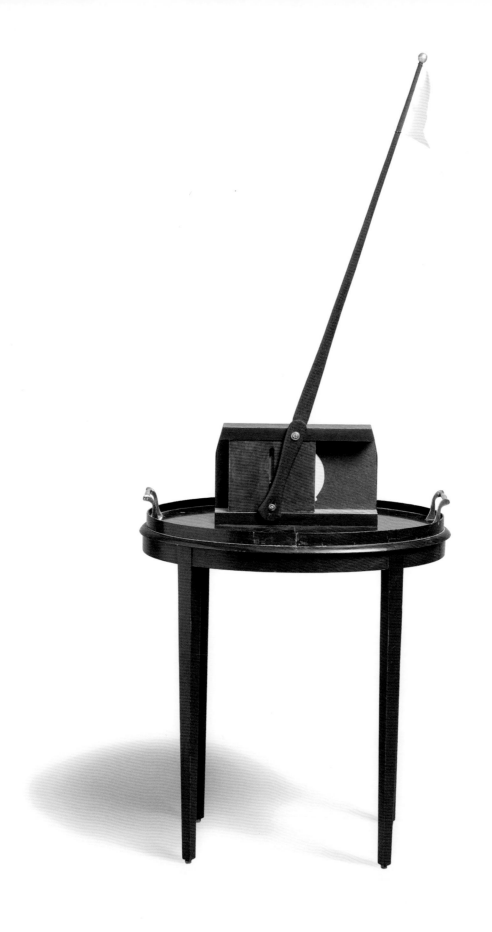

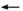

Capitulation Device, 2014
Butler's tray, motor, plywood, cloth
28 x 19 x 13 in.

following pages:
Fountain, 2014, 2017
Carved wood, MDF, motors, audio, pump, bucket, colored water
66 x 33 x 40 in.
details follow

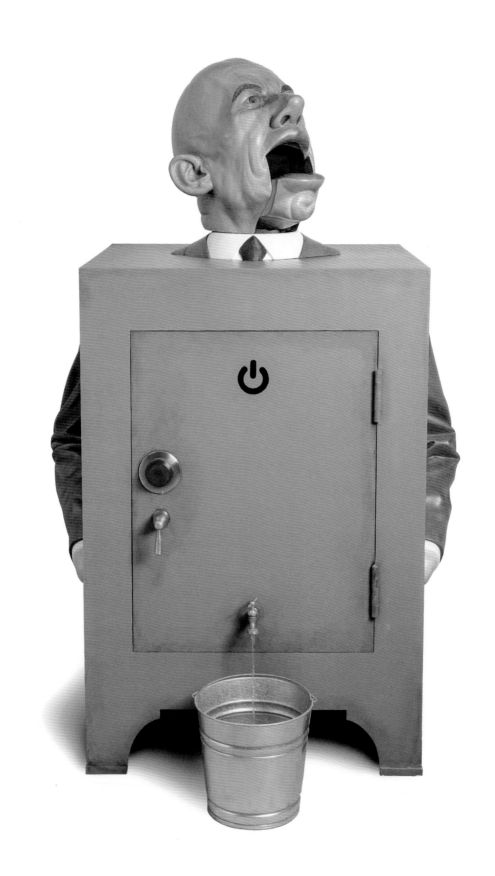

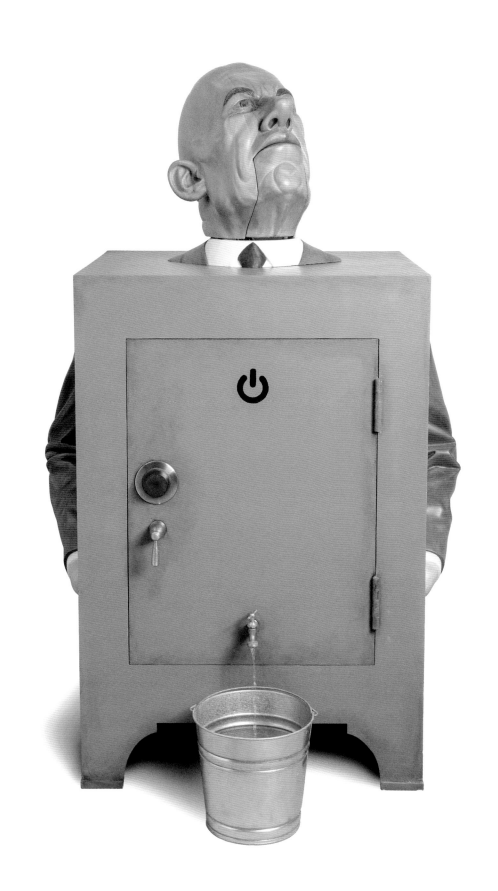

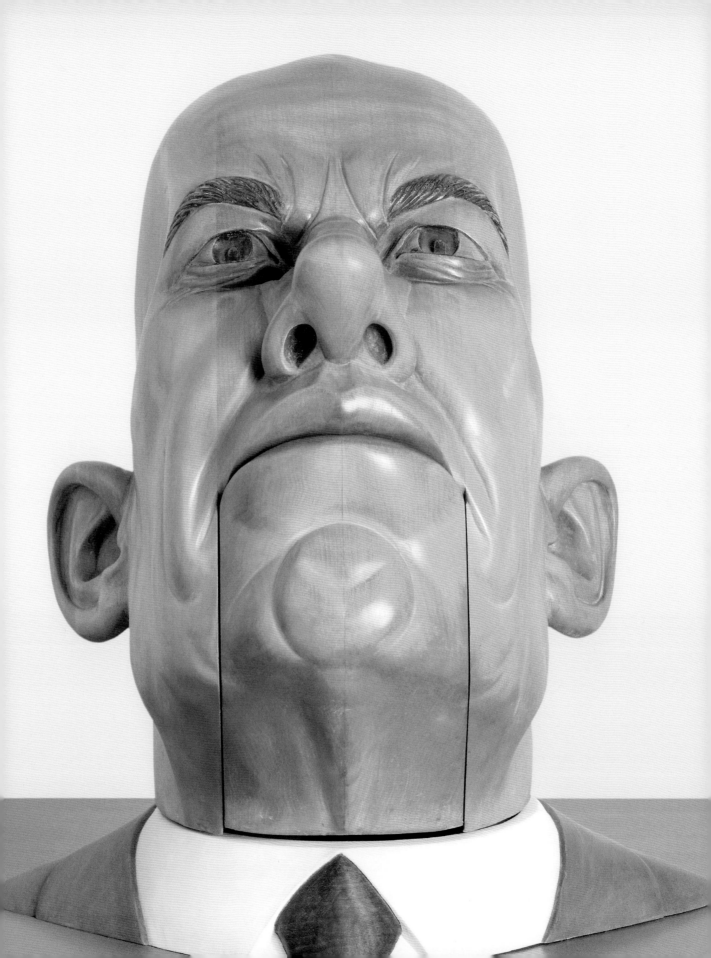

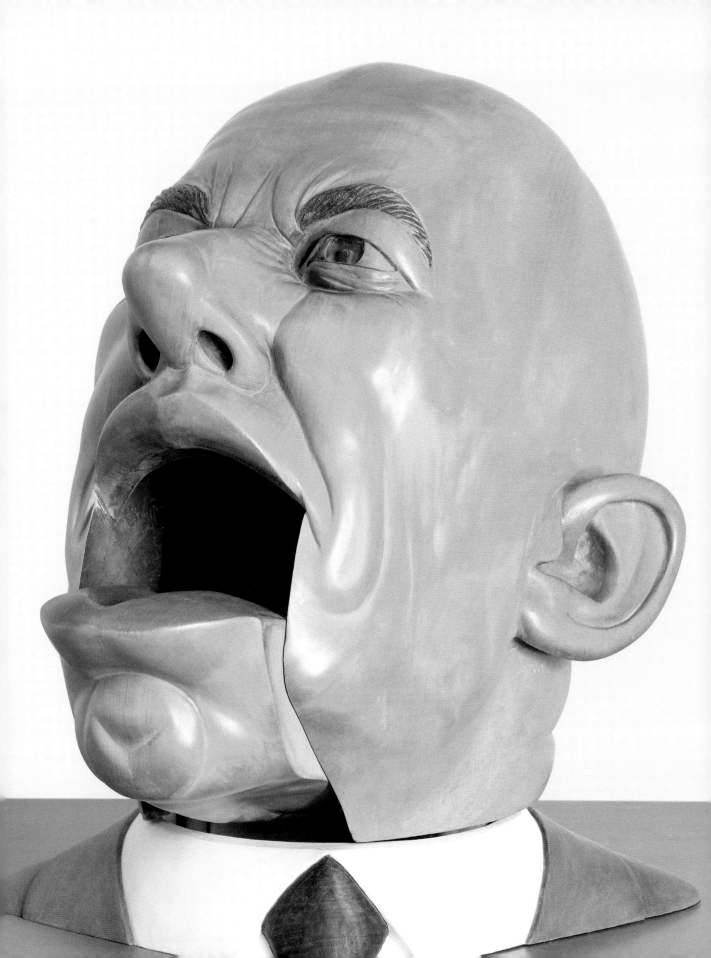

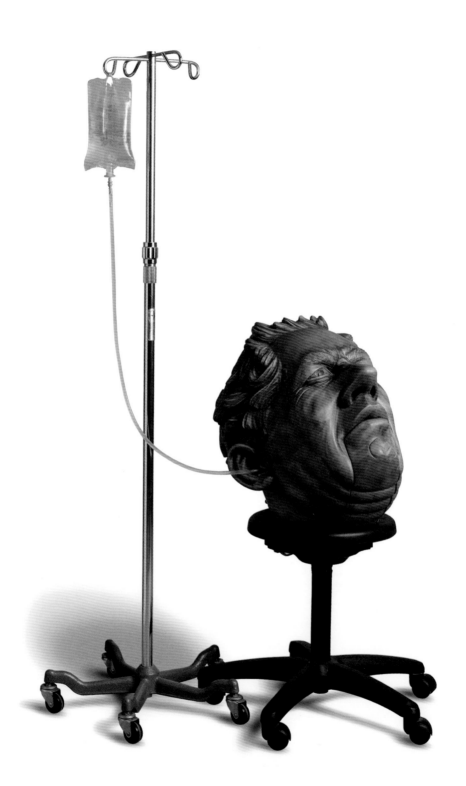

Slow Drip, 2014
Carved wood, MDF, motors, audio, pump, bucket, colored water
51 x 43 x 40 in.
detail on following pages

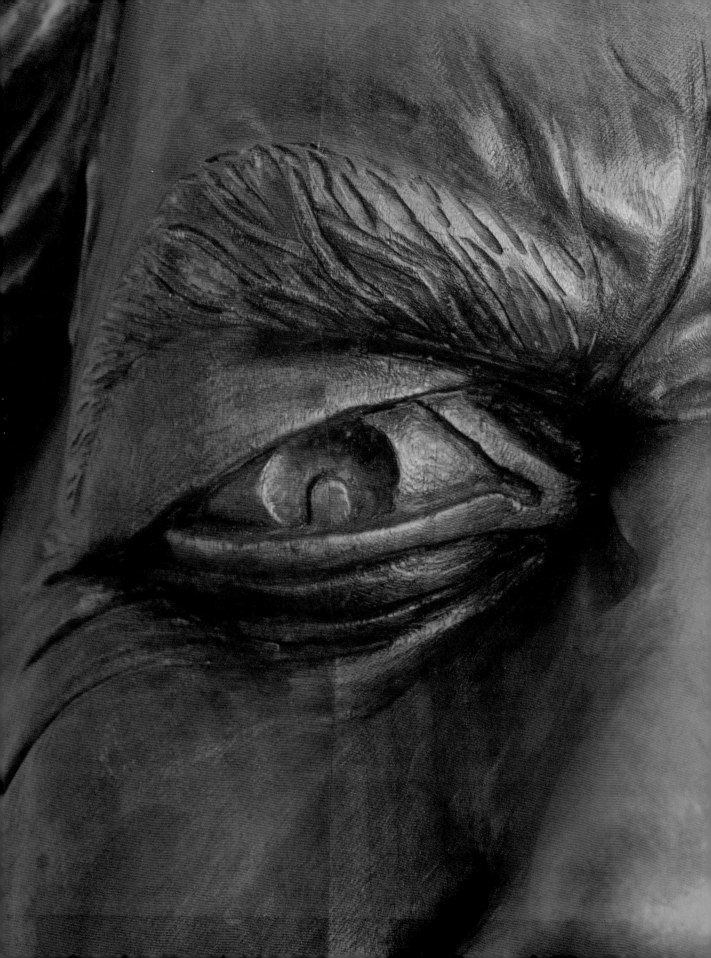

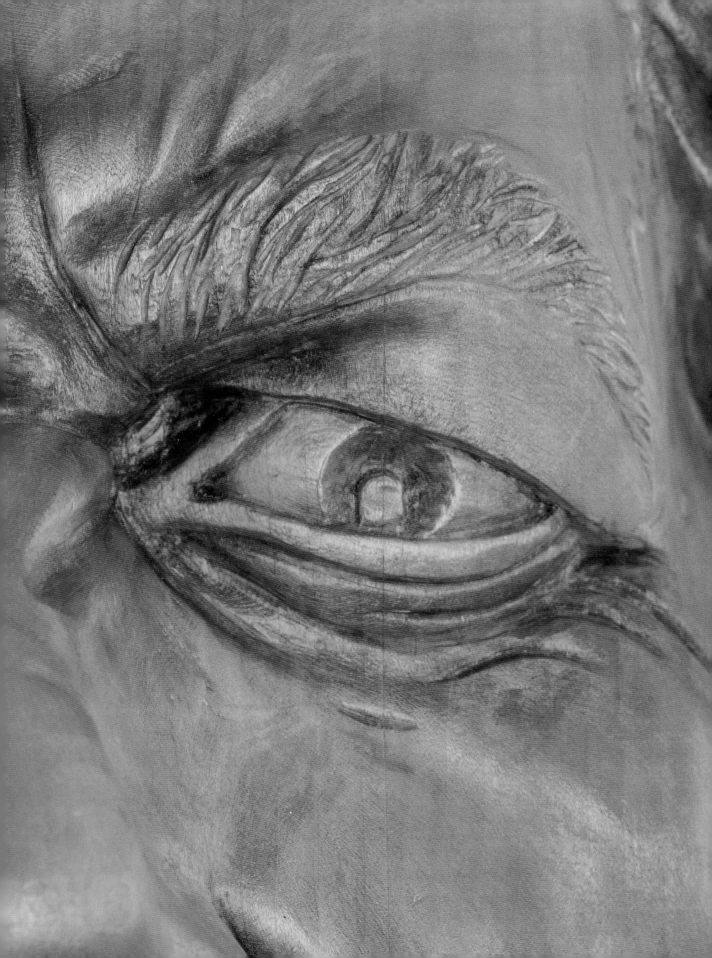

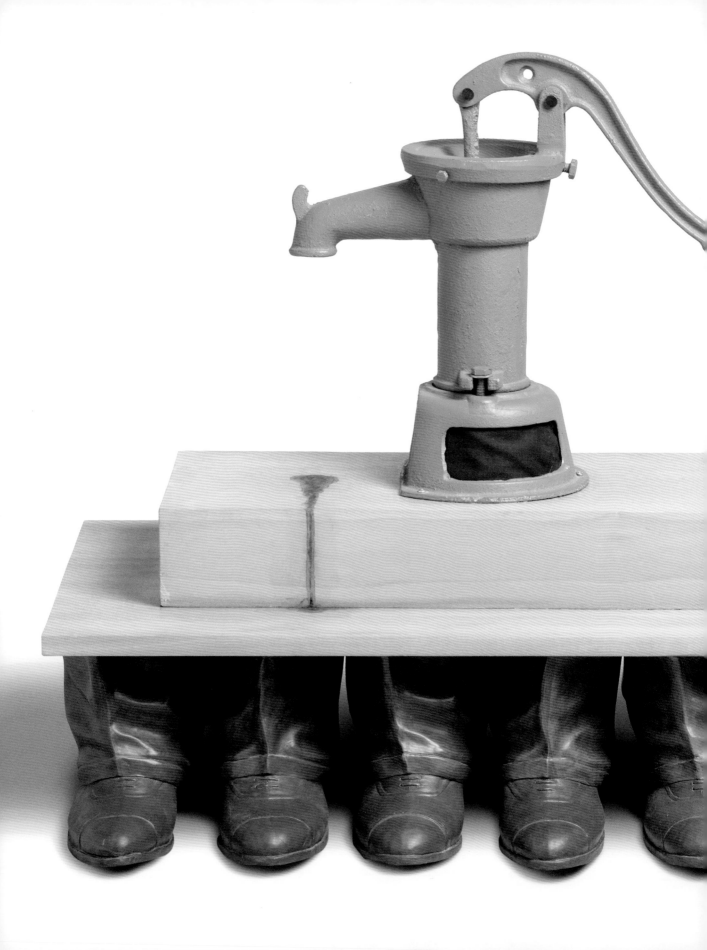

←

Stain, 2014
Pump, terra cotta, wood, motor, audio, paint
28 x 32 x 25 in.

following pages:
Trumpeter, 2014
Carved wood, fiberglass, audio, casein, wax
59 x 30 x 14 in.
detail follows

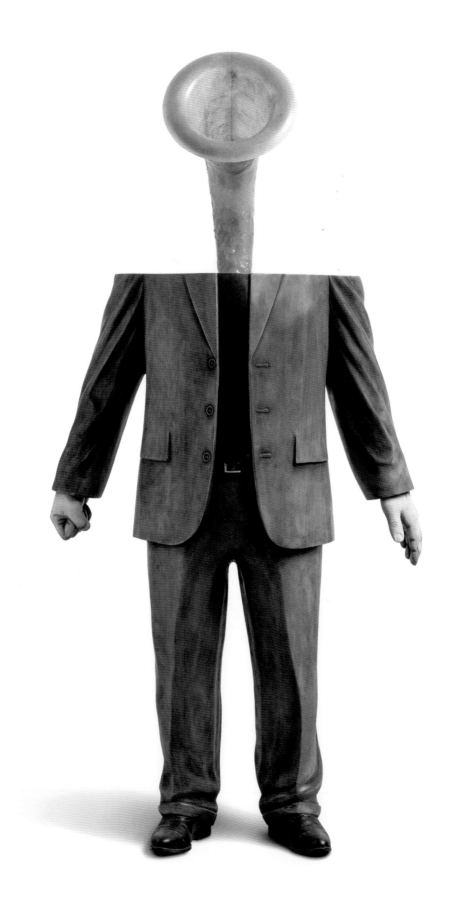

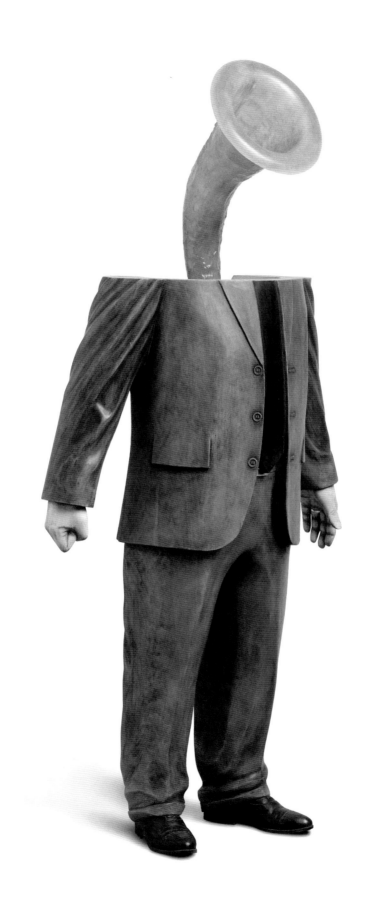

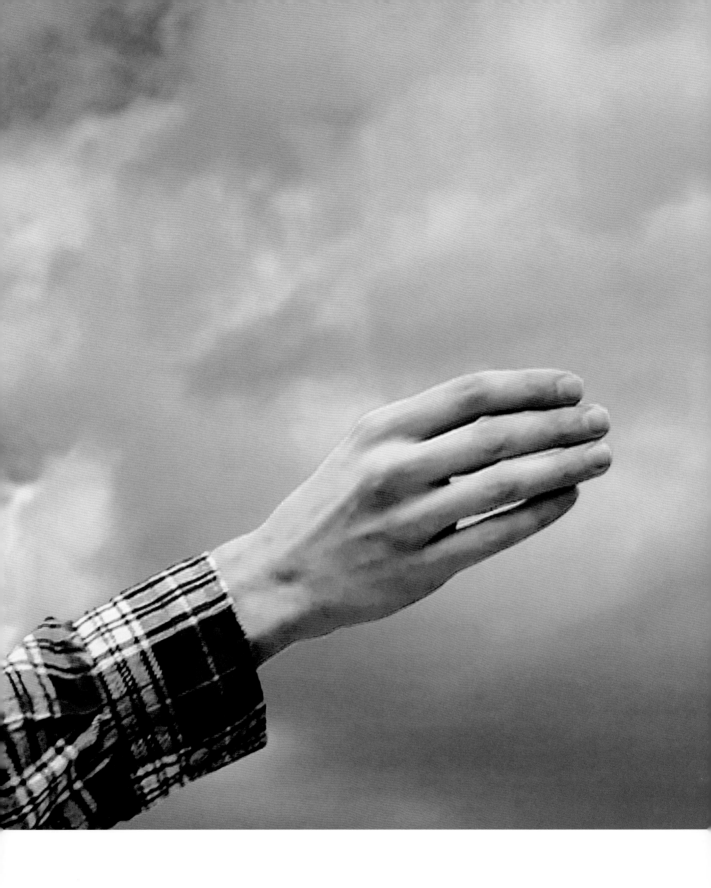

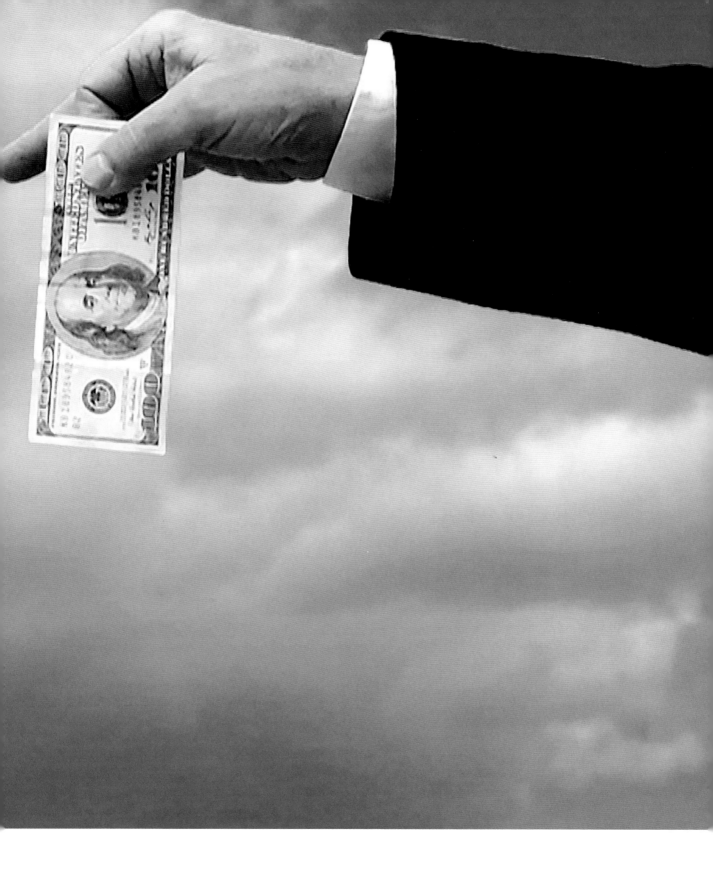

Upper Hand, 2014
Video still, with Bart Trotman (2:56)

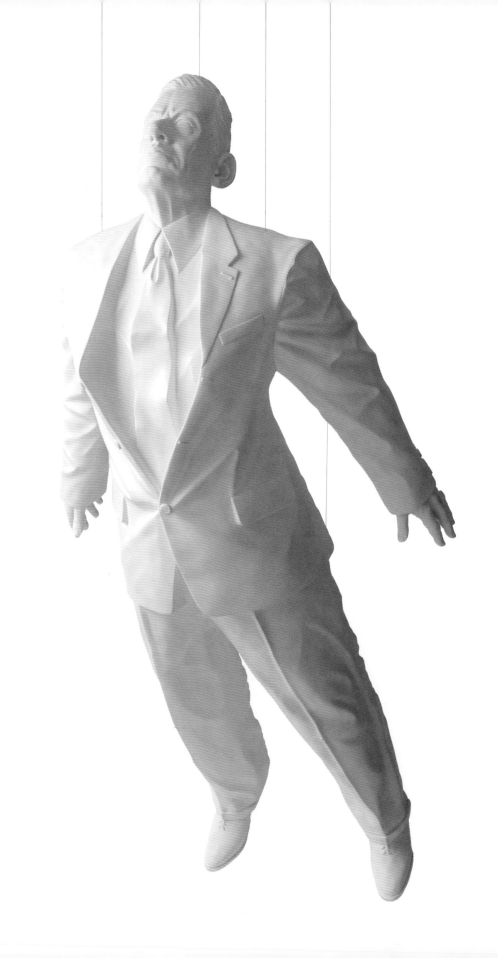

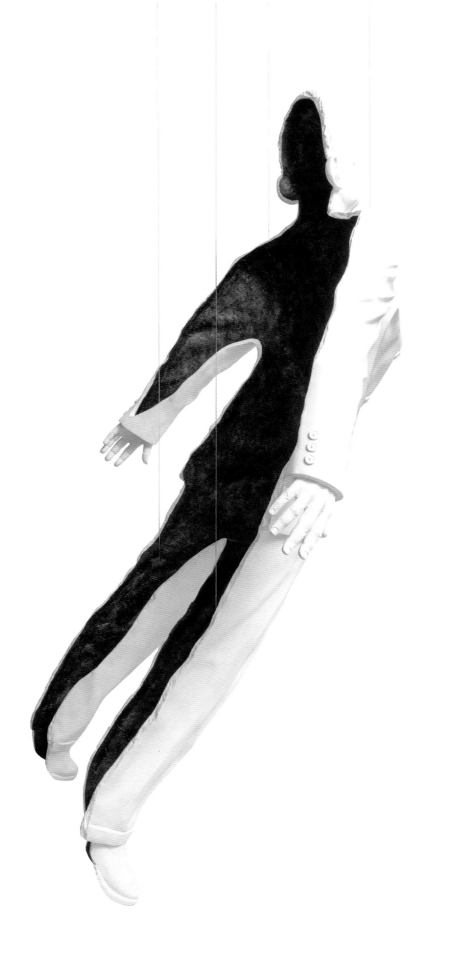

White Man, 2015
Urethane resin
96 x 44 x 26 in.
details on following pages

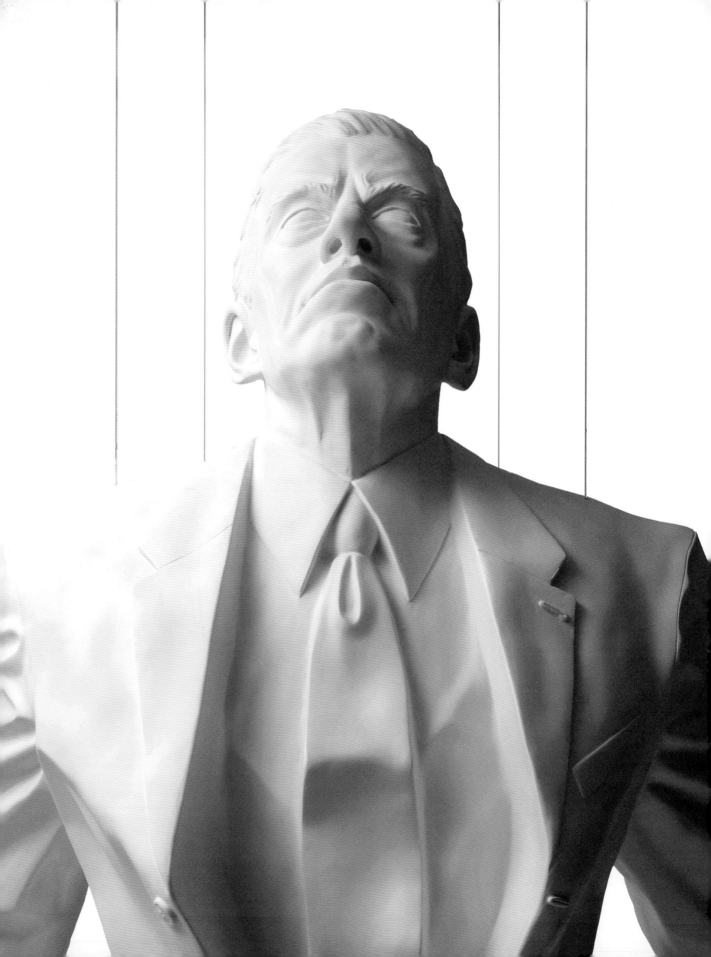

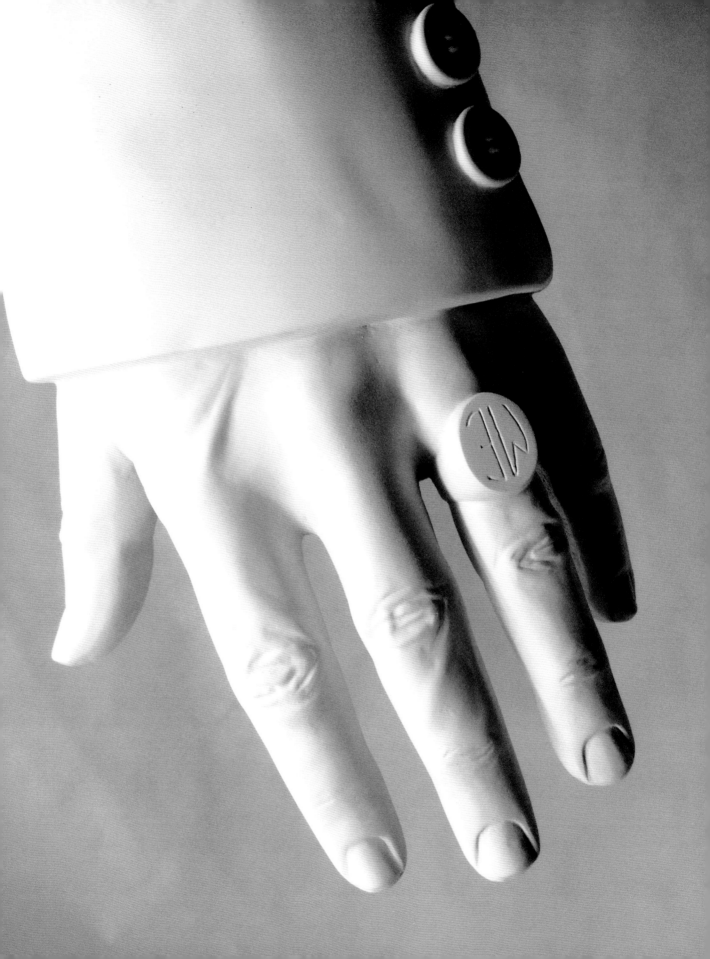

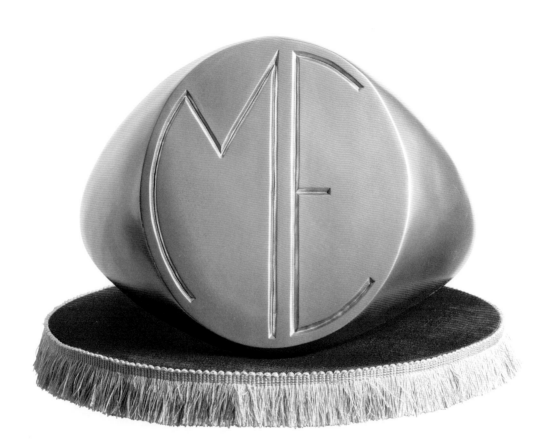

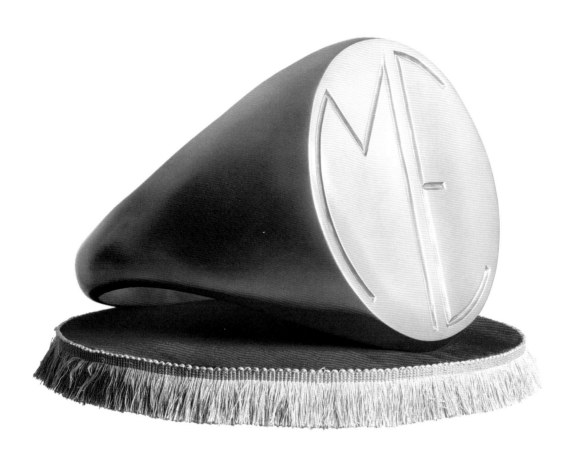

Me Ring, 2016
Urethane resin, Bondo, aluminum,
steel, paint, cloth, wood, turntable
16 x 20 x 20 in.

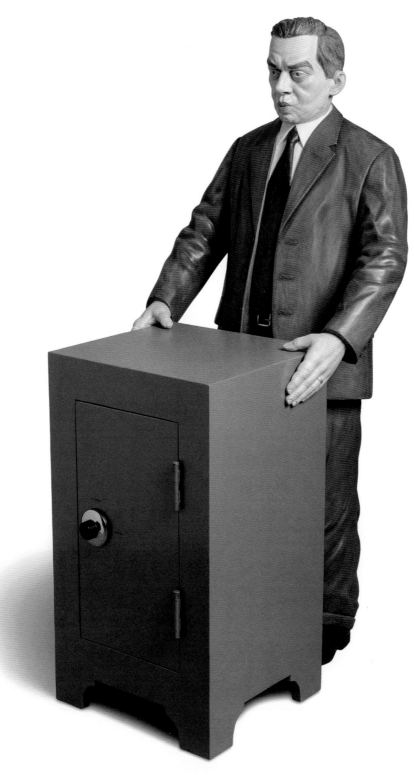

Safe Sex, 2016
Wood, motor, tempera, wax
46 x 22 x 19 in.

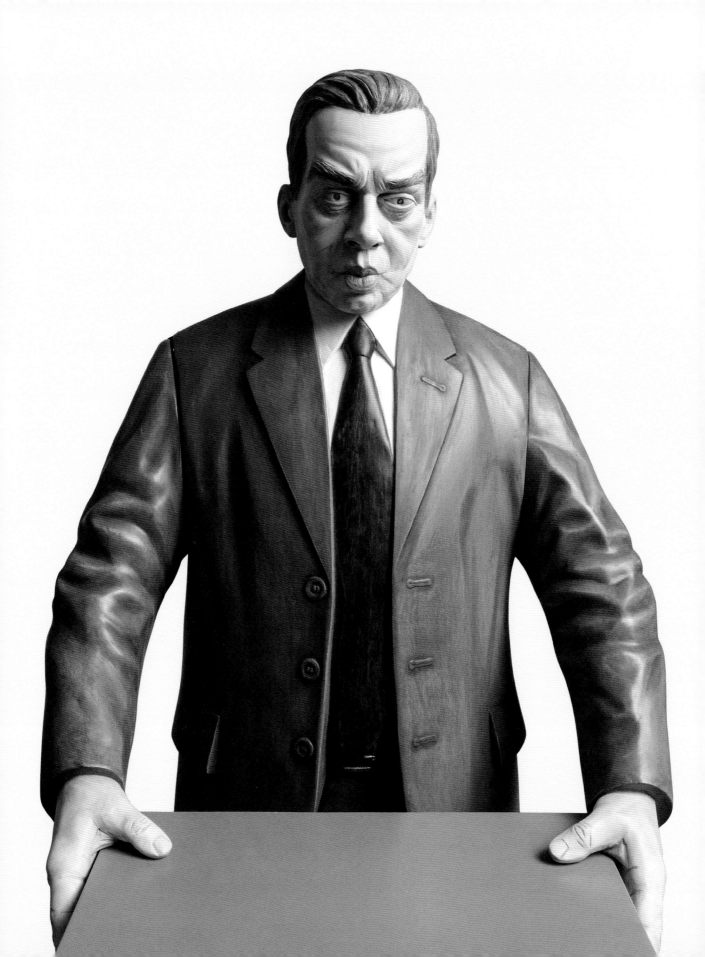

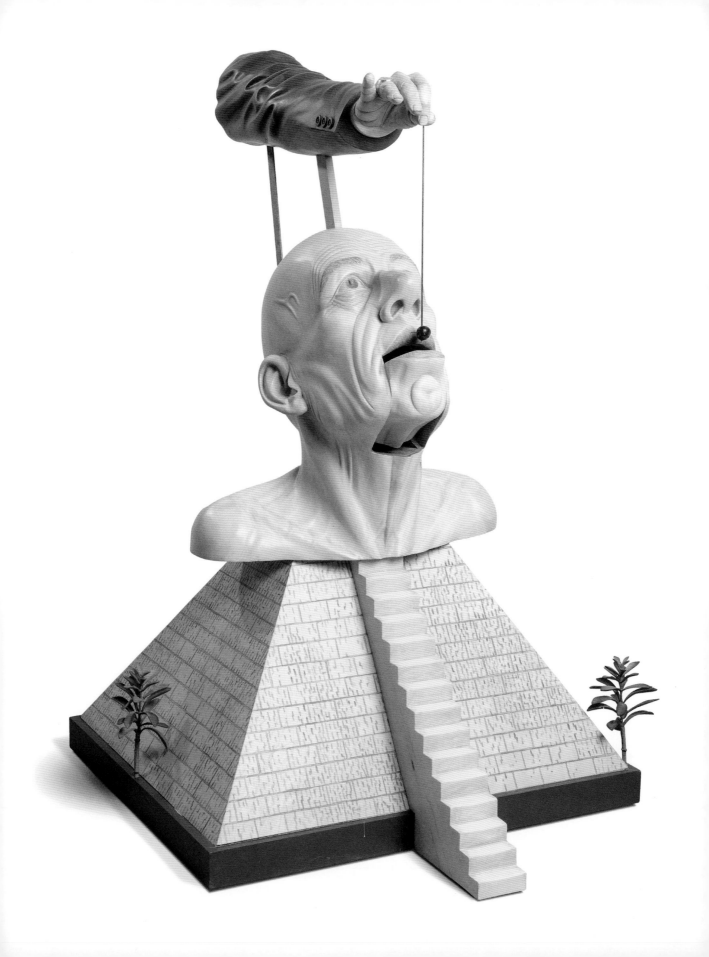

Denier, 2016
Carved wood, plywood, steel, bronze,
motor, artificial plant
62 x 36 x 38 in.
detail on following page

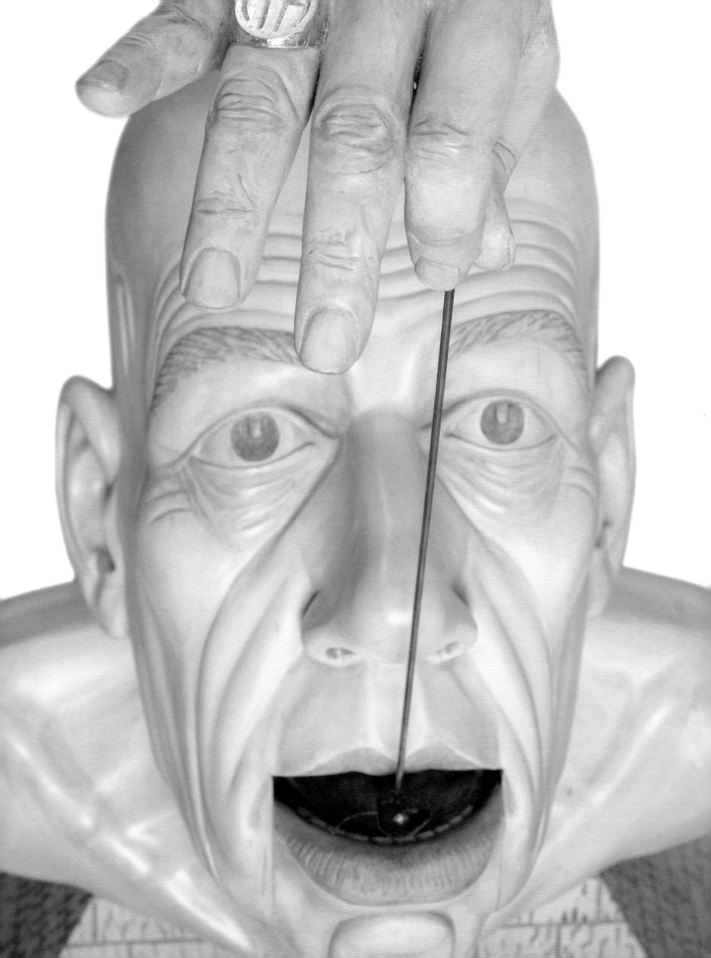

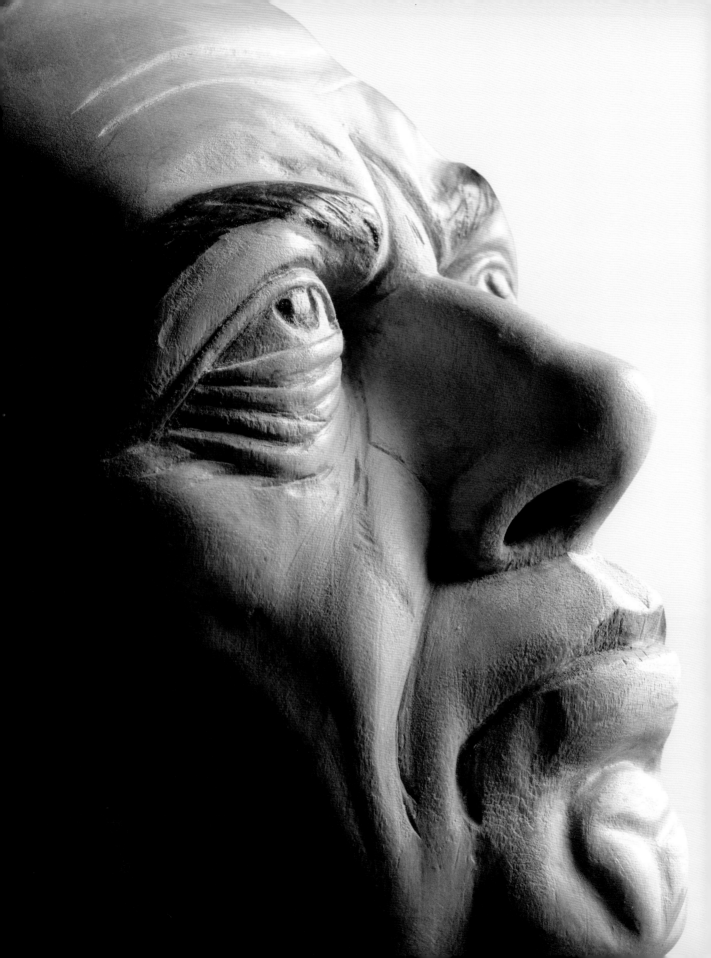

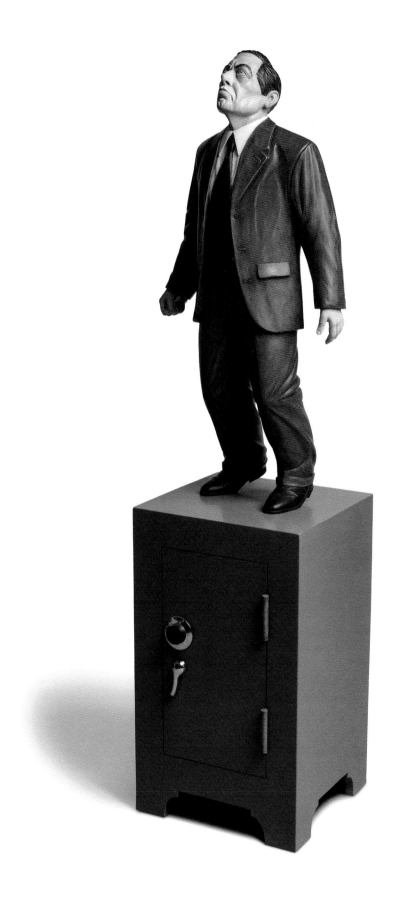

Senior Partner, 2014, 2016
Carved wood, paint, plywood, hardware
58 x 14 x 13 in.

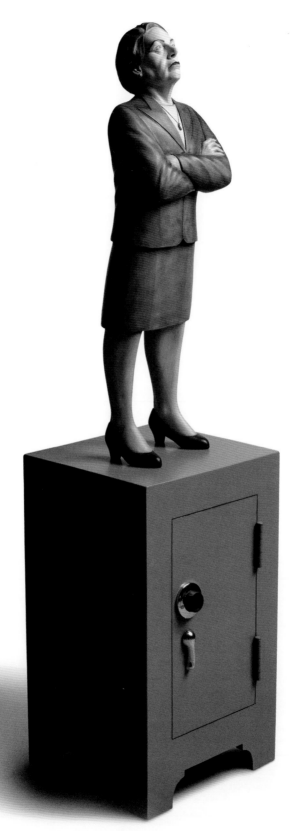

Senior Partner, 2016
Carved wood, paint, plywood, hardware
54 x 14 x 13 in.

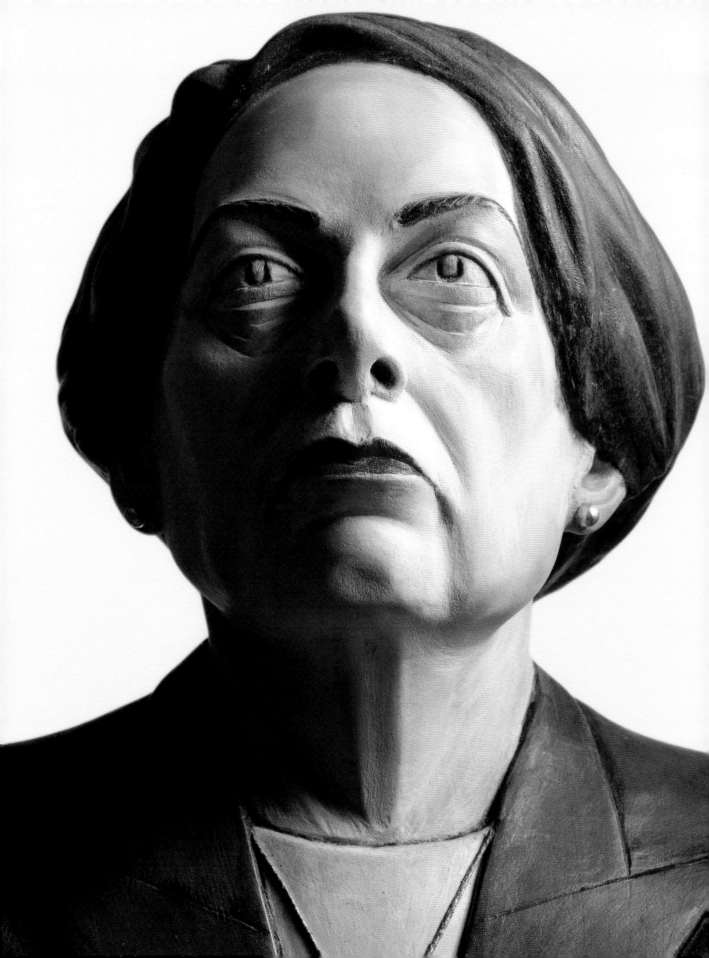

Swan Dive, 2013
Graphite and gouache
9 x 12 in.

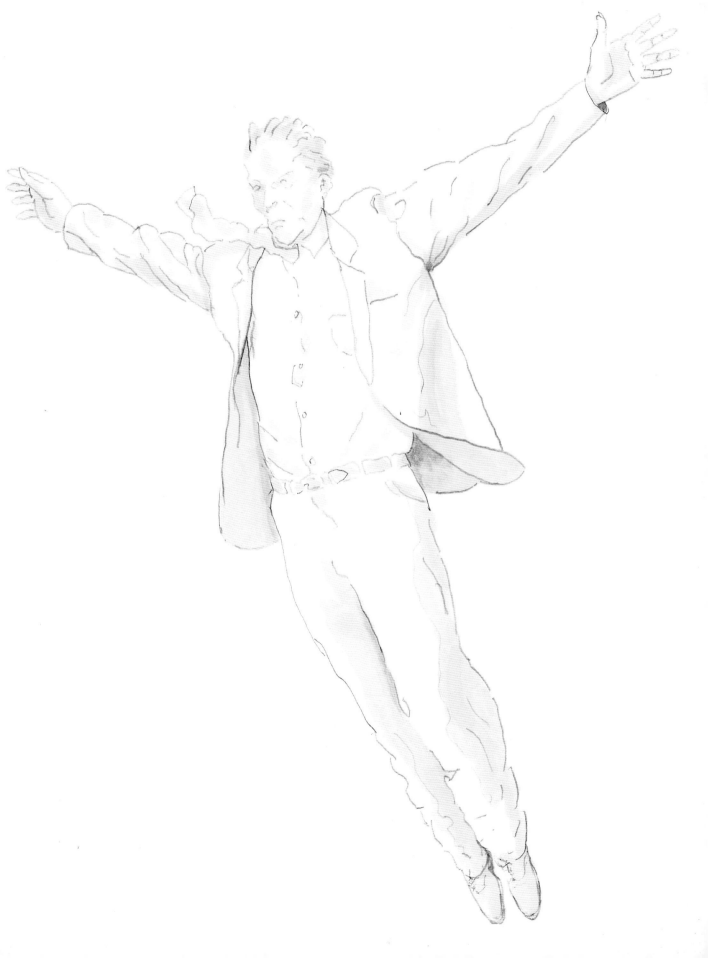

Bob Trotman in Conversation with Crista Cammaroto

Crista Cammaroto: As an artist for thirty-five years, you have consistently been able to portray the cracking facade of the stressed corporate individual with a critical satire but also with a bit of compassion. How do you tease out the allegorical expressions from the wood?

Bob Trotman: Actually, I've been at it for forty-two years now, although quite a bit of that time was spent as a studio furniture maker. I devoted myself exclusively to sculpture twenty years ago. The sculptural element had evolved gradually in my furniture until I finally allowed it to take over and stand on its own. When that happened and I no longer had a functional pretext for my objects, I was obliged to put something compelling in its place, and that, for me, was the struggle for self-determination in the face of standardized social pressures. That is the implicit dilemma of my wooden characters, too, whether they realize it or not: authentic existence versus "wealth and success."

CC: The characters that you often present on a first-name basis have served as timeless harbingers of the unbridled capitalism in our country and the world economy. We have all lived the benefits and trials of this, the story and these questions are ongoing throughout your work. In today's investigations of our most corporate presidency to date, your work reignites as some of these same questions of character bubble forward daily in the news, and in the current theater of capitalism. Does this light a fire in you to make more work?

BT: I have always felt an urgency toward creative work that comes from someplace inside me much deeper than politics. When it comes to politics, however, crusading may be necessary, but I must remind myself that it does not necessarily make good art. Talking back to authority is important, though, and it resonates with my personal psychology and philosophy background, so if I can use that impulse in a way that is rich and interesting enough, so much the better, especially now, but I don't want to make editorial cartoons or be too specific. I prefer to think about the big forces behind the players. I also want to leave room for other elements that may have nothing to do with politics but that combine to make a sculpture memorable.

CC: Knowing that it is important to move beyond contemporary anxiousness when looking at the breadth of your work, what are the deeper philosophical and timeless narratives that you consistently look through, or work through, when conceiving your work?

BT: I am most interested in the play of power and its attendant ironies. For me, personally, this started in my relationship with my father, a banker, who was emotionally remote and authoritarian, as were many fathers of his generation.

The challenge for me as an artist is to tap into that pool of emotional residue and use it imaginatively to frame what I see in current events and history. The encounter with autocratic power is deeply shocking, both for a child and for an adult, whether it comes from a parent or a government or a corporation.

CC: Your process of making has multiple levels of careful consideration for each work; beginning with sketches, using clay to create maquettes for each figure, working different angles for each character, and then playing with the figurative forms together to work out the politics of their space. Can you talk about the many ways you play with space, both aesthetically and politically? How would you position your own characters to stage what you see as the story of 2017?

BT: One space I am interested in is the "interpersonal" space between the viewer and the sculpture. The sculptures are usually looking at the viewer, as if returning the viewer's gaze. Small sculptures look up. Large sculptures look down. The size of the sculpture relative to the viewer's body affects the viewer's sense of his own power in relation to the person that the sculpture suggests. There is a hierarchy. Size matters. A large scowling face can be intimidating. A small one can be comical. Think of the relations of children and adults, workers, and bosses.

When I am working I love to lose myself in the topography of, say, a face, as if it were a vast landscape. I often think of the end of Hitchcock's *North by Northwest*,

which takes place on the face of Mount Rushmore. At the very close range required for detailing, a face can become godlike or else totally abstract, an arrangement of hills and valleys, depressions and promontories, complex shapes to be exaggerated and refined.

I am always playing with the spatial arrangement of the sculptures in relation to each other and to other installation elements, like artificial office plants, but I find this less powerful than the fundamental relation of the sculpture to the viewer, probably because, fictionally speaking, it is at a double remove. That is the trouble with tableaux: the fictive relation between two fictions (the characters) starts running out of steam.

The passage of time can also alter my display choices. For years I showed a large writhing figure on a desklike pedestal, but the "desk" eventually became dead to me, just a prop. Now I am showing the figure directly on the floor. The view is simplified, compressed, and much more ambiguous in relation to the viewer's body. I think very slowly. It takes me time to see things, to get over infatuations, to distill my vision. That distillation does not happen in relation to a philosophical precept, but in relation to my own gut response in encountering my work over and over and over again, fresh each day as I enter the studio. I bring with me, of course, a sense of what is happening in the world, and that is always changing, too. There is often a subtle evolution that goes beyond my original idea and that process requires the passage of some time: a bit of aging, I suppose. In the end, the sculptures tend to grow a little beyond what prompted them.

CC: You have chosen to live in a kind of rural solitude, surrounding yourself with more space and time to consider. Does this distance from the fast lane of society inform your work and your process of making art?

BT: Having quiet space around me is an indescribable luxury. I like what Flaubert said about living a sensible, quiet life so you could be bold with your art. I am very focused and work every day. There is so much I want to do. I don't think my solitude so much informs my work as it allows me to do it. Other people have a tendency to bowl me over. I lose my bearings too easily. I actually had to isolate myself in order to become an artist at all. I know that isolation can be a handicap, but, on balance, I think it works for me. There is a lot I don't know, both technically and artistically, so when I am with knowledgeable people, I am very inquisitive. Online videos are extremely helpful, as is the occasional workshop. I also hire technical help when I need to.

CC: Pulling from the worlds of philosophy, literature, music, art, and pop culture, who have been the more significant influences on you during your long career as an artist? What is your reflection on how these artists have shaped our world?

BT: Among contemporary artists, I greatly admire William Kentridge. As a white South African, he deals with issues of class, labor, race, and social justice through various media, including video, drawing, and sculpture. He came from a theater and puppetry background and makes dramatic use of irony, humor, and even whimsy, which despite myself I love. Looking back in art history, I also admire the work of Brueghel [the Elder], Goya, and Daumier for their interest in social issues and [use of] ironic expression. Messerschmidt's "character heads" and Riemenscheider's wooden saints still have much to teach me.

As to literature, Kafka still ranks as a favorite. His short stories and parables hint at central mysteries but ultimately defy interpretation (a mark of great art, in my opinion). I like Beckett for similar reasons. Do you know the contemporary Spanish novelist Javier Marías? His work has that same feeling that I love, of a mystery hidden in plain sight.

I loved the Talking Heads back in the 1980s and groups like Radiohead and Björk now. Jonny Greenwood's film scores and Steve Reich's minimalist compositions would also be high on my chart in a more classical vein.

My study of philosophy has been much more about asking questions than about finding answers. It has taught me how to live with doubt and uncertainty, and to generally value skepticism over belief. Philosophy was a stage in my quest back when I thought there was "truth" to be known. When I encounter it now, I'm still interested, but it seems so thin and dry. Art brings much more into the arena, both in the viewing and (especially) in the making. The life of the artist tops even that. I consider myself extremely lucky to be able to live that life. Maybe "truth" is more something to be lived rather than just known.

Crista Cammaroto
Director of Galleries
University of North Carolina at Charlotte

Bob Trotman
Born Winston-Salem, NC, 1947

Grants and Awards

1984, 1995, 2000, 2010	North Carolina Arts Council, Artist Fellowship
1984, 1988	National Endowment for the Arts, Artist Fellowship

Education

1969	B.A. Philosophy, Washington and Lee University, Lexington, VA *Magna Cum Laude, Phi Beta Kappa*
1976	Jon Brooks, Penland School of Crafts, Penland, NC
1977	Sam Maloof, Penland School of Crafts, Penland, NC
1985	James Surls, Atlantic Center for the Arts, New Smyrna Beach, FL
1986	Robert Morris, Atlantic Center for the Arts, New Smyrna Beach, FL
1988	Francesco Rivera, Sculpture Center, New York, NY

Selected Solo Exhibitions

2018	Gregg Museum of Art & Design, NC State University, Raleigh, NC
2017	Van Every/Smith Galleries, Davidson College, Davidson, NC
2017	Projective Eye Gallery, University of North Carolina at Charlotte, Charlotte, NC
2016	Southeastern Center for Contemporary Art, Winston-Salem, NC
2014	Visual Arts Center, Richmond, VA
2014	Halsey Institute of Contemporary Art, College of Charleston, Charleston, SC
2012	Morris Museum of Art, Augusta, GA
2010	North Carolina Museum of Art, Raleigh, NC
2008–10	Mint Museum of Art, Charlotte, NC
	Stainer Gallery, Washington and Lee University, Lexington, VA
	Cameron Museum of Art, Wilmington, NC
	Greenville County Museum of Art, Greenville, SC
2006	Frist Center for the Visual Arts, Nashville, TN
2002	Hand Workshop, Richmond, VA
2002	Weatherspoon Art Museum, University of North Carolina at Greensboro, Greensboro, NC
2001	Franklin Parrasch Gallery, New York, NY
1998	Franklin Parrasch Gallery, New York, NY
1996	Franklin Parrasch Gallery, New York, NY
1995	Mint Museum of Art, Charlotte, NC
1994	Gregg Museum of Art & Design, NC State University, Raleigh, NC
1993	Sandler Hudson Gallery, Atlanta, GA
1992	Nexus Contemporary Art Center, Atlanta, GA

Selected Group Exhibitions

2017	*State of the Art*, Mint Museum of Art, Charlotte, NC
2017	*State of the Art*, Dixon Gallery, Memphis, TN
2017	*State of the Art*, Frist Center for the Visual Arts, Nashville, TN
2016	*State of the Art*, Jepson Center for the Arts, Telfair Museums, Savannah, GA
2014	*State of the Art*, Crystal Bridges Museum of American Art, Bentonville, AR
2011	*Connections: Marilyn Murphy & Bob Trotman*, Huntsville Museum of Art, Huntsville, AL
2011	Houston Fine Arts Fair, Jerald Melberg Gallery, Houston, TX
1990	*Art That Works*, national traveling show (Lloyd Herman, curator)
1986	*Poetry of the Physical*, national traveling show (Paul Smith, curator)

Selected Collections

Columbia Museum of Art, Columbia, SC
North Carolina Museum of Art, Raleigh, NC
Virginia Museum of Fine Arts, Richmond, VA
Museum of Art and Design, New York, NY
Renwick Gallery, Smithsonian Institution, Washington, D.C.
Museum of Art, Rhode Island School of Design, Providence, RI
Gregg Museum of Art & Design, NC State University, Raleigh, NC
Vice President's Residence, Washington, D.C.
Asheville Art Museum, Asheville, NC
Weatherspoon Art Museum, University of North Carolina at Greensboro, Greensboro, NC
Hickory Museum of Art, Hickory, NC
Museum of Art, Arizona State University, Tempe, AZ
Wake Forest University, Winston-Salem, NC
Frances and Sydney Lewis Collection, Richmond, VA

Selected Bibliography

Castle, Wendell. "The Leading Edge." *Popular Mechanics* (November 1986).

Gionvannini, Joseph. "Chairs That Roar." *The New York Times*, March 19, 1987.

Hanzal, Carla. "Interview with Bob Trotman." Oral history interview. Archives of American Art, Smithsonian Institution, 2005.

Heartney, Eleanor. "Art and the Spiritual." *Thresholds: Expressions of Art & Spiritual Life*. SC Arts Commission (2003).

———— "Bob Trotman: Capitalism as Religion." In *Bob Trotman: Inverted Utopias*. Raleigh: North Carolina Museum of Art, 2010.

Kistler, Ashley. "Bob Trotman: Model Citizens." Essay for the Hand Workshop, Richmond, VA, 2002.

Koplos, Janet. "Bob Trotman at Franklin Parrasch." Exhibition review of Bob Trotman at Frankin Parrasch Gallery. *Art in America* (October 2001).

Leach, Mark R. "ArtCurrents 20: Bob Trotman." Interview with the artist. Mint Museum of Art, 1995.

Meyer, Jon. "1988 Mint Museum of Art Biennial." *ARTNews* (September 1988).

Plagens, Peter. "The State of State of the Art." *Wall Street Journal*, September, 2014.

Ryan, Dinah. "Bob Trotman at Hand Workshop Art Center." *Sculpture* (December 2002).

Sloan, Mark, et al. *Bob Trotman: Business as Usual*. Charleston: Halsey Institute of Contemporary Art, 2017.

Washburn, Mark. "Interview with Bob Trotman." *Sculpture* (January/February 2011).

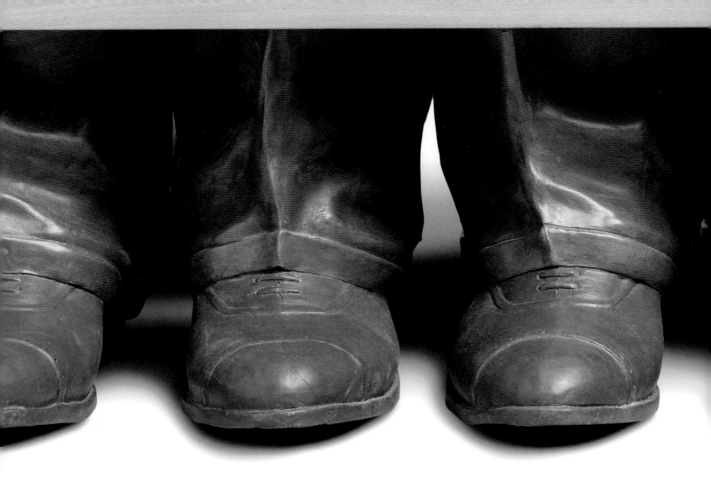

Acknowledgements:

This exhibition would not have been possible without the support of the Lewis-Butler Foundation; the Herb Jackson and Laura Grosch Gallery Fund; Elizabeth Firestone Graham Foundation; Malú Alvarez, Davidson College Class of 2002; the Davidson College Friends of the Arts, the College of Arts + Architecture at UNC Charlotte, the Gregg Museum of Art & Design, NC State University, and the N.C. Arts Council, a division of the Department of Natural & Cultural Resources. We would also like to thank Chris Vitiello and Ken Lambla.

Lenders to the exhibition:

Sanford Berlin
Andrew Dews
Suzanne and Elmar Fetscher
Jeff Pettus
Hedy Fischer and Randy Shull
Bob Trotman
The Mint Museum, Charlotte, NC
North Carolina Museum of Art, Raleigh, NC

Special thanks to:

Caroline Wright

North
Carolina
Arts
Council
*Fifty years
of leadership*

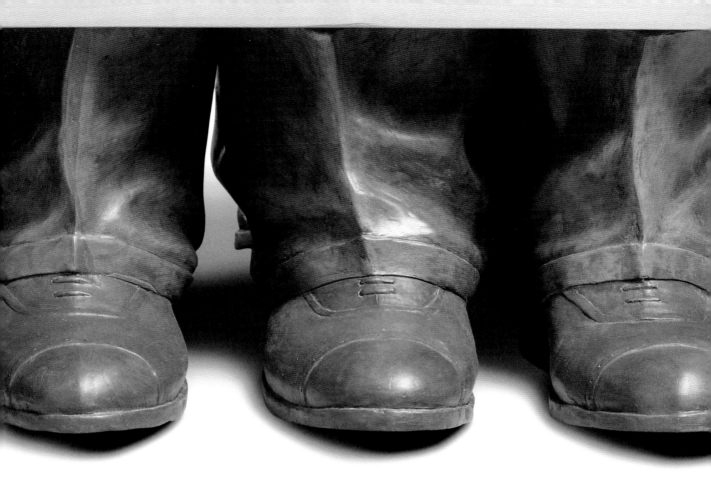

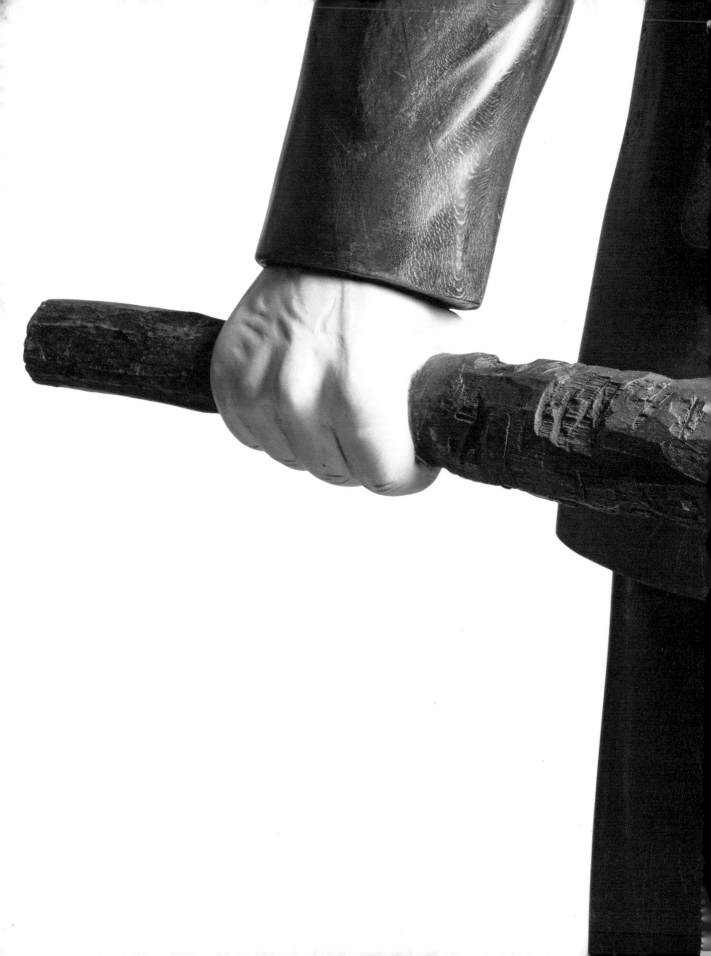